KU-130-085

Hillwood *Museum* *&Gardens*

Marjorie Merriweather Post's Art Collector's Personal Museum

With contributions by

Frederick Fisher

Karen Kettering

Anne Odom

Liana Paredes Arend

Gwen Stauffer

Published by
Hillwood Museum
and Gardens
Washington, DC

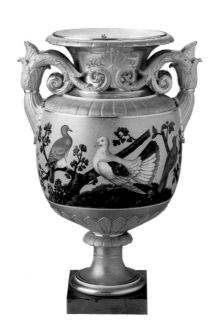

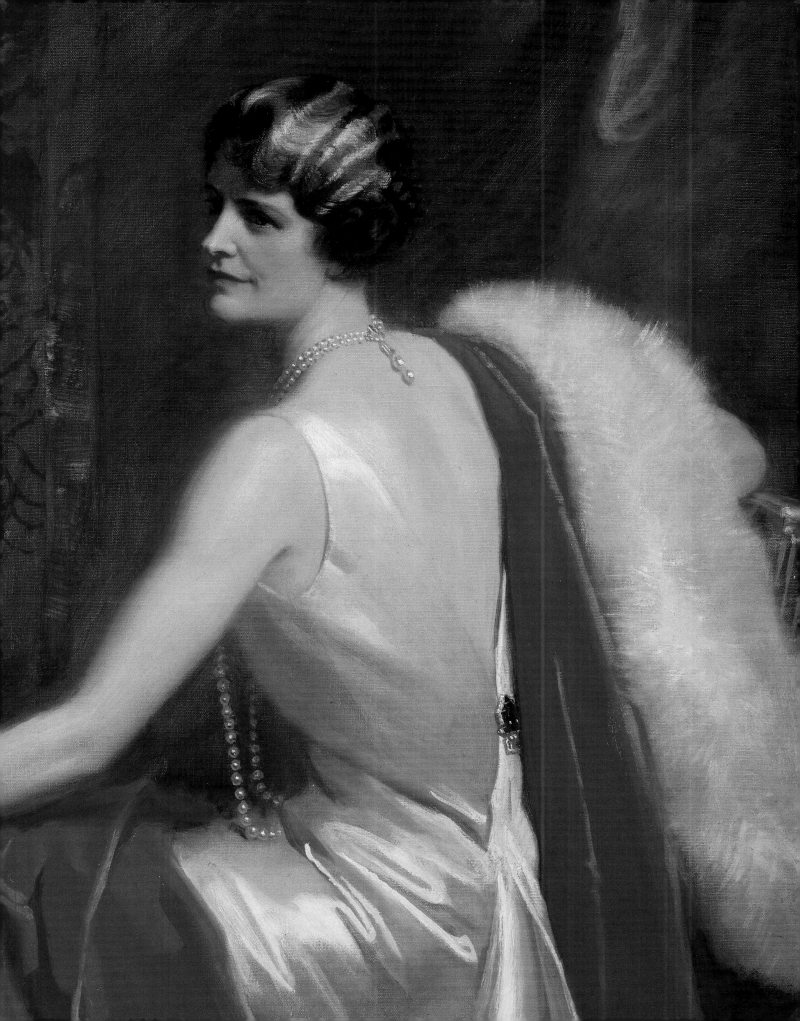

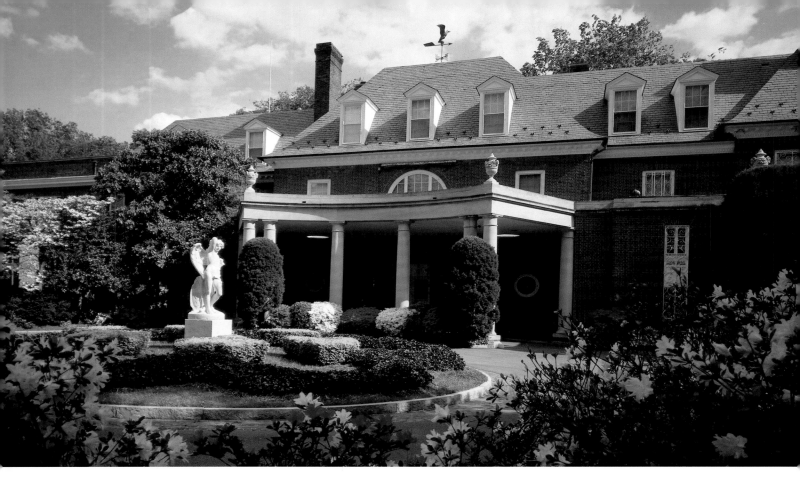

Above

Hillwood Mansion
North Façade

Cover: Hillwood Mansion
South Façade

p. 1: Vase with Pigeons,
Imperial Porcelain Factory
St. Petersburg, late 1830s-early 1840s

pp. 2–3: Detail of
Portrait of Marjorie Merriweather Post
Frank O. Salisbury, 1934

©2000 Hillwood Museum and Gardens, Washington, D.C. All rights reserved.

ISBN 0-9654958-8-4 (hardcover)
ISBN 0-9654958-9-2 (paperback)

Library of Congress Cataloging-in-Publication Data
Hillwood Museum and Gardens.
 Hillwood Museum and Gardens: Marjorie Merriweather Post's art collector's personal museum/with contributions by Frederick Fisher . . . [et al.].
 p. cm.
 ISBN 0-9654958-8-4 (hardcover: alk. paper)—ISBN 0-9654958-9-2 (pbk.: alk. paper)
 1. Post, Marjorie Merriweather-—Art collections. 2. Art—Private collections—Washington (D.C.) 3. Hillwood Museum and Gardens. I. Fisher, Frederick. II. Title.
 N858.H54 A875 2000
 708.15—dc21
 00-010503

Contents

Introduction
page 6

Hillwood: An Art Collector's Personal Museum
page 8

The Lasting Legacy of Marjorie Merriweather Post
page 14

A Tour of the Estate

The Mansion
page 26

The Gardens and Auxiliary Buildings
page 46

Highlights of the Collection

The French Collection
page 58

The Russian Collection
page 76

Reigns of French and Russian Monarchs
page 98

Plants of Seasonal Interest
page 100

An Overview of the Estate
page 102

Detail of Vase
(cuvette "Mahon")
Sèvres, 1757

Introduction

Frederick J. Fisher, Executive Director

In the world of museums, Hillwood Museum and Gardens holds a unique position owing to the fact that it possesses the largest representative collection of imperial Russian fine and decorative arts outside Russia. Displayed in the former home of its collector and founder, Marjorie Merriweather Post, Russian objects are combined with eighteenth- and ninteenth-century French and European decorative arts, much as they would have been arranged in the imperial estates and palaces of the Romanovs. Located in Northwest Washington, D.C., Hillwood offers visitors a tranquil oasis nestled on a twenty-five acre landscaped estate surrounded by natural woods.

This book provides the context in which to more fully appreciate Marjorie Merriweather Post, her magnificent collection, and her beautiful estate. Born in Springfield, Illinois, in 1887, the only child of Charles William Post, founder of the coffee substitute Postum and Post Cereals, this beautiful and forward-thinking woman maintained an elegant lifestyle while ever attentive to collecting, business, and philanthropic activities. She developed her signature style during the waning days of America's Gilded Age, carrying it forward to the mid-twentieth century.

Mrs. Post perfected her collecting skills during the 1920s when she acquired some of the finest examples of French eighteenth-century decorative arts for her elegant New York City apartment. But her pioneering collecting experience began in the late 1930s when she was exposed to Russian art—on Russian soil—as wife of the American ambassador to the Soviet Union, Joseph E. Davies.

In the mid-1950s she purchased Hillwood, redesigning it to suit her lavish entertaining, and more important, to function as an eventual museum. Hillwood opened to the public in 1977 and is operated by the Hillwood Museum and Gardens Foundation. The board and staff's vision for the museum is that it will continue to honor the extraordinary legacy of Marjorie Merriweather Post and develop to their fullest potential the resources she left in trust for future generations.

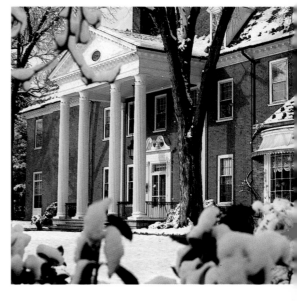

Above

Hillwood South Façade in winter

Opposite

Detail of
Commode with Floral Marquetry
Attributed to Jean-Henri Riesener
Paris, ca. 1775–80

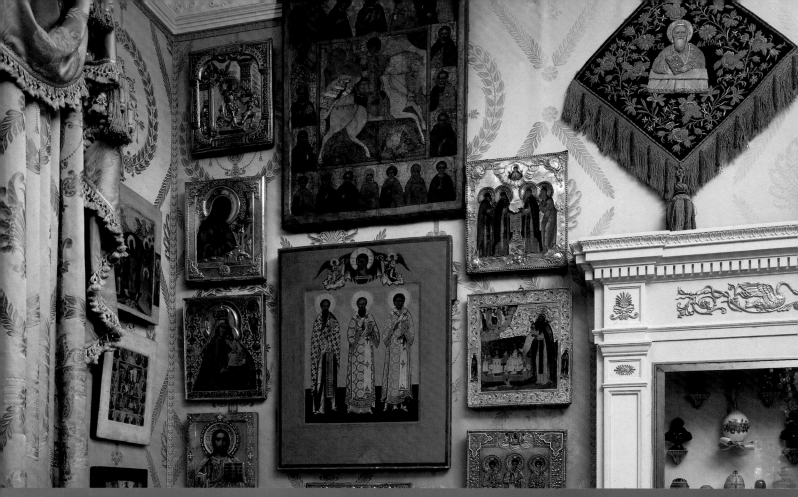
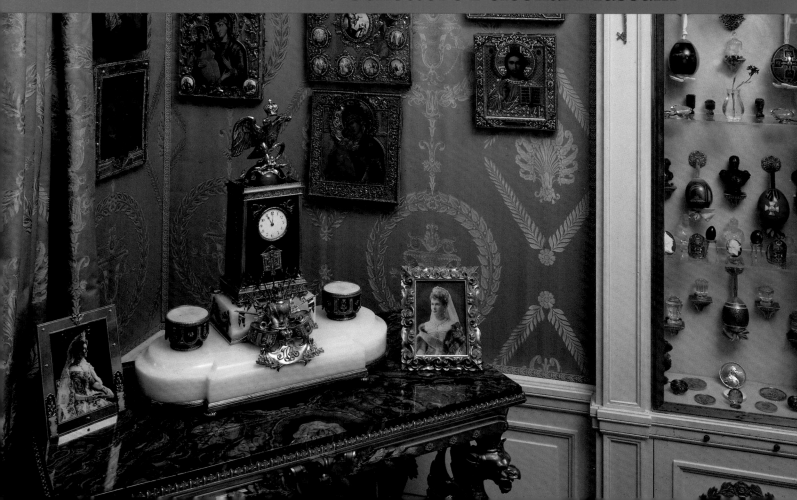

Hillwood: An Art Collector's Personal Museum

Marjorie Merriweather Post's Washington, D.C., estate, Hillwood Museum and Gardens, exemplifies a rare type of American museum known as the art collector's personal museum. The founders of these national jewels followed a pattern set in Europe, where since the Renaissance, princes and wealthy individuals have transformed their domiciles into showcases for art. Like their counterparts abroad, American collectors bestowed a public legacy by turning their homes into museums highlighting the fruits of their collecting interests.

Opposite

Hillwood Icon Room

Above

Hillwood Entry Hall

Right

The Long Gallery, The Isabella Stewart Gardner Museum, Boston, Massachusetts

These collections range from important Old Master paintings and stellar examples of contemporary art to European and American decorative arts. Most founders of personal museums wanted the public to experience their treasures within the same ambiance they designed and built to contain them. Today, approximately twenty-four such museums exist throughout the nation. However, not all reflect their original appearance, due to structural changes needed to fulfill obligatory conservation requirements and facilitate effective interpretation of the works of art.

Moreover, some personal museums have added to the collections after their founder's death. Art collector's personal museums should, also, not be confused with the plethora of house museums scattered across America whose typical function is to highlight a historical figure or period lifestyle. Although most house museums contain assemblages of household furnishings, some extremely valuable, their owners were not serious art collectors.

The first American to establish a personal museum is the Boston art collector, Isabella Stewart Gardner (1840–1924). The daring Mrs. Gardner delighted in challenging Boston blue bloods when, in 1903, she opened her home, Fenway Court, to the public. She included in her will a proviso that after her death it never be altered. Hers was not a typical New England home but a melange of Venetian architectural fragments installed around an interior three-story courtyard. Scattered throughout the spaces, esoteric and magnificent Old Master paintings share living quarters with an idiosyncratic mix of antiques and memorabilia. Mrs. Gardner, like

many subsequent art collectors, developed the idea for creating such an exotic space in America from her many travels abroad. When American collectors visited European family estates with fine and decorative arts collections, they returned home with a desire to make up for the absence of Old World culture in America.

An American collector who

Below

The Fragonard Room, The Frick Collection, New York, New York

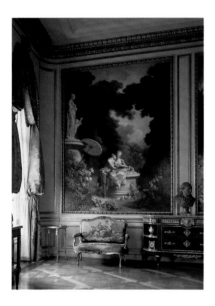

emulated Mrs. Gardner's example was Henry Clay Frick (1849–1919). The Pittsburgh coke and steel industrialist began collecting art at age thirty-one on his first trip to Europe with his friend Andrew Mellon—who also became an important art collector. By the turn of the century, Frick's extraordinary eye for quality had led him to acquire some of the finest paintings and decorative arts in America. In 1913 he and architect Thomas Hastings created

his upper Fifth Avenue, New York City, residence after the style of eighteenth-century European aristocratic domestic architecture. Throughout the mansion, his magnificent paintings are elegantly set among fine French furnishings and decorative arts. Like Mrs. Gardner in Boston, Frick intended his home and collection to become a museum after his death. However, he did not stipulate that it remain frozen in time as did Mrs. Gardner, but allowed for future expansion of the facility and collection.

Across the continent, in San Marino, California, Henry E. (1850–1927) and Arabella (1850–1924) Huntington transformed their majestic estate into the Huntington Library, Art Collections and Botanical Gardens. As its name implies, the Huntington is more than an art museum, reflecting the couple's multiple avocations. Huntington made his wealth as a railroad executive, initially co-managing the Southern Pacific Company and later organizing the Los Angeles interurban railway system. He began buying art in the early 1900s, but it wasn't until he married his second wife, Arabella, that he became a serious collector. Indeed, it was she who nurtured his art-collecting passion. Together they amassed one of America's finest assemblages of eighteenth-century English paintings and decorative arts, including such masterpieces as Thomas Gainsborough's *Blue Boy* and Sir Thomas Lawrence's *Pinkie*.

The Huntingtons' 207-acre site also includes an outstanding botanical garden of approximately 150 acres. Like Frick, Huntington

conceived of his estate as a living institution that could evolve over time. Today, the couple's fine and decorative arts collections appear in a variety of spaces in their home and library, some as originally arranged and others in galleries retrofitted from former living quarters. Over the years, the Huntington has acquired additional art collections, the library has grown exponentially, and the botanical garden has become a renowned educational facility.

The Barnes Foundation, located in suburban Merion outside of Philadelphia, represents a personal collector's museum of quite a different nature. Founded by the eccentric Dr. Albert C. Barnes (1872–1951), it ranks as one of the world's finest private collections of Impressionist, Post-Impressionist, and early modern art. Barnes made a sizable fortune from his invention and manufacture of Argyrol, an antiseptic for the treatment of eye inflammation. In the second decade of the twentieth century, he began assembling a number of paintings by America's early modernist painters to decorate his manufacturing plant and expose his workers to the educational benefits of art.

Later, with the assistance of American realist artist William Glackens, Barnes acquired a great number of paintings by contemporary European artists including Vincent Van Gogh, Paul Cézanne, and Henri Matisse—a pioneer collector indeed. Unlike other collectors, he did not live with his collection but built an adjacent gallery on his property for its display. Highly suspicious of academic art historians, Barnes developed his

Left

The Library Room, The Huntington Library, Art Collections and Botanical Gardens, San Marino, California

own obscure philosophy of art education that led him to decorate his gallery, floor-to-ceiling, with works of art totally out of chronological sequence and juxtaposed to a strange assortment of decorative objects and metal hardware fragments from all over.

Opened to the public in 1951 in the Brandywine Valley near Wilmington, Delaware, the magnificent Winterthur estate of Henry Francis du Pont (1889–1969) has become a local landmark. The beautiful rolling terrain was settled by du Pont's ancestors—founders of America's black powder industry—in 1810. He inherited it upon his father's death in 1926. Formally educated in practical horticulture, du Pont eventually developed an interest in collecting American antiques. At the end of his life, he possessed the most comprehensive collection of objects made or used in America before 1840.

In addition, he purchased numerous period interiors from structures slated for demolition that enabled him to create authentic spaces for the display of his collections. Du Pont enlarged the family home several times to properly mount items from his vast collection. The seriousness of du Pont's avocation is attested to in his attention to research and conservation, leading him eventually to establish a research library and conservation center.

Du Pont had a colleague collector—or one might say a competitor—in Ima Hogg of Houston, Texas (1882–1975). Formally educated to be a concert pianist, she decided not to pursue a musical career, but instead enjoyed the comforts of family wealth based on oil holdings and real estate. Early in her life, Hogg acquired a passion for fine and decorative arts of several categories including European contemporary paintings on paper, the arts of Southwest Indians, and, what she is best remembered for, American decorative arts from the colonial period up to the Victorian era.

In 1926 she built her home Bayou Bend (much smaller in scale than du Pont's Winterthur) in the suburbs of Houston. There she spent the rest of her life expanding and refining her magnificent American fine and decorative arts collection. Like du Pont, she organized her collection according to periods and displayed them in appropriately styled rooms. At age seventy-five Hogg deeded Bayou Bend to the Museum of Fine Arts, Houston, with the provision of life tenancy. She stipulated that it remain forever a house museum

Below

The Port Royal Parlor, The Henry Francis du Pont Winterthur Museum, Winterthur, Delaware

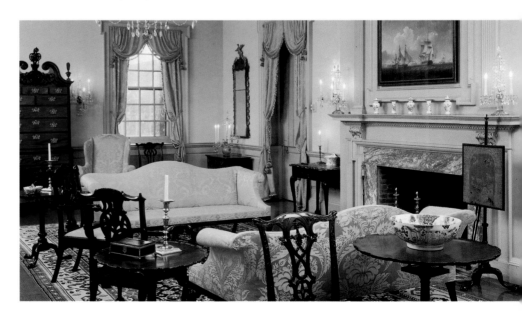

for the display of her American collection. It opened to the public in 1966.

Another house museum of nearly the same scale as Bayou Bend is the Hyde Collection in Glens Falls, New York. However, that is where the similarity ends. Louis Fiske (1866–1934) and Charlotte Pruyn (1867–1963) Hyde's fine and decorative arts collection takes this brief survey of American art collector's personal museums back full circle to Isabella Stewart Gardner's Fenway Court. The Hydes modeled their

span of western art history from the Renaissance to the early twentieth century. In 1963, after Mrs. Hyde's death, the couple's home opened to the public with the proviso that it remain intact as a museum to benefit the communities in the foothills of the Adirondack Mountains. Unfortunately, its remote location makes it one of the lesser known art collector's personal museums.

While space does not allow descriptions of other art collector's personal museums, a few deserve mention. Among the more noted

amass such troves in unrefined America. In reality, they also thought of themselves as artists, creating rooms with extraordinary atmosphere for the display of their treasures. Unlike kindred collectors such as J. P. Morgan, Andrew Mellon, and Samuel Kress—who preferred to bequeath their collections to large American public museums—these individuals sought to retain for posterity a personal association with their possessions—making these personal museums veritable acts of self-expression.

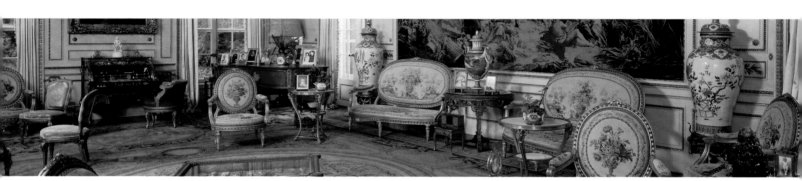

home—built on the banks of the Hudson River overlooking the pulp paper factory that was the source of their wealth—on an Italian Renaissance villa. Young students in Boston when Gardner was creating her museum, the couple later fell under the spell of living with Old Master paintings and Renaissance decorative arts.

While their wealth did not match most of the other serious art collectors, they judiciously accumulated a small but significant representation of art covering the

Above

Hillwood French Drawing Room
(see page 30)

are the John and Mable Ringling Museum of Art, Sarasota, Florida; the Taft Museum, Cincinnati, Ohio; the Hill-Stead Museum, Farmington, Connecticut; and in Washington, D.C., Dumbarton Oaks, the Phillips Collection, and the recently opened Kreeger Museum.

By allowing the public to experience great art in intimate spaces—as much of it was originally meant to be seen— founders of these museums left a special legacy. Most of them traveled extensively, bringing them into contact with the art treasures held in European public and private collections. They longed to

Strong-willed and fascinating individuals founded each of these rare and special American museums. They drafted legal trusts to ensure that their legacies of magnificent fine and decorative arts remain in perpetuity for the public's pleasure. For many well-traveled museumgoers, these art collector's personal museums stand out as special places in which to experience art's magic and become acquainted with vivid personalities such as Marjorie Merriweather Post.

When I began [collecting],

I did it for the joy of it, and it

was only as the collections grew

and such great interest was

evidenced by others that I came

to the realization the collection

should belong to the country.

Marjorie Merriweather Post

1970

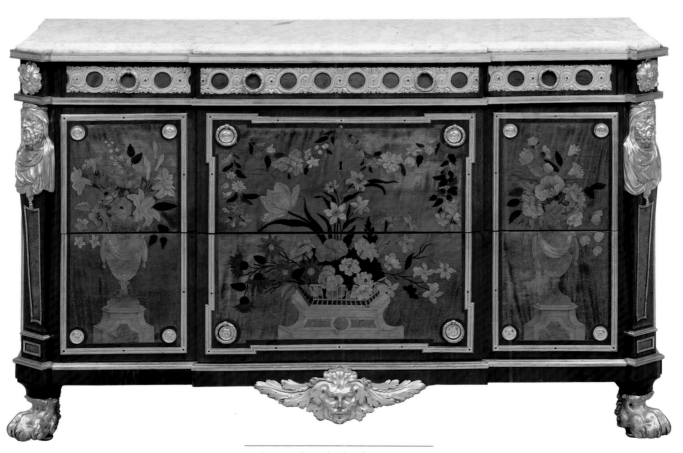

Commode with Floral Marquetry
Attributed to Jean-Henri Riesener
Paris, ca. 1775–80

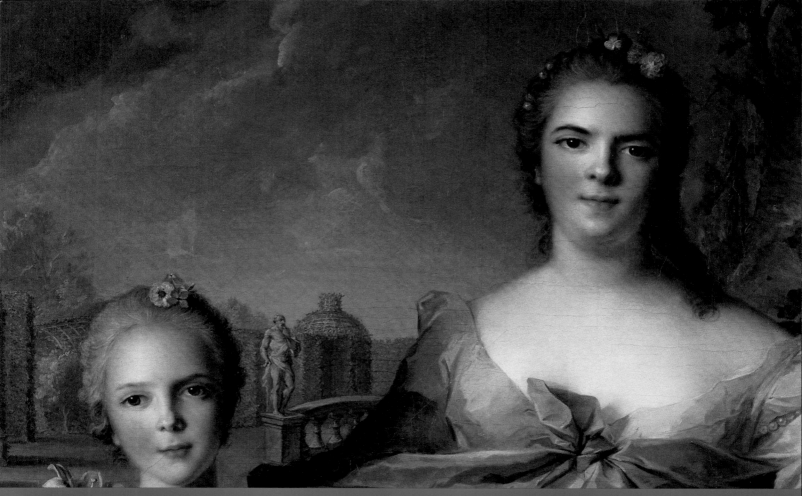

The Lasting Legacy of Marjorie Merriweather Post

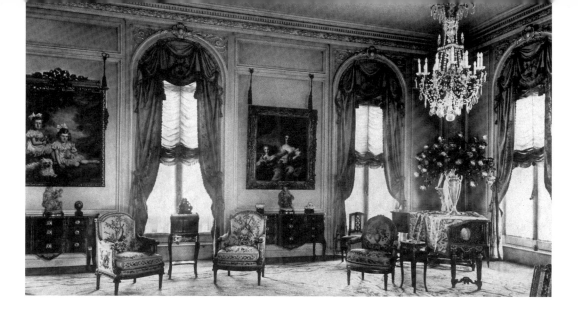

Marjorie Merriweather Post

(1887–1973)

deserves a place in the arena of

great twentieth-century

American collectors. Her lasting

legacy, the Hillwood Museum

and Gardens, attests to her

vision as a collector.

Opposite

Detail of *The Duchess of Parma and Her Daughter Isabelle*
Jean-Marc Nattier, 1750

Above

Drawing Room of the Burden
Mansion, New York, New York
ca. 1920

Marjorie Merriweather Post was the only daughter of C.W. Post, founder of the Post cereal company of Battle Creek, Michigan. On her eighteenth birthday in 1905, she became the richest woman in America in her own right with assets amounting to $2 million. That same year she married Edward Bennett Close, a Columbia University law student and member of a distinguished Greenwich, Connecticut, family.

The genesis of Mrs. Post's career as a collector harks back to the early part of the twentieth century and coincides with her move to New York City. In 1916 the Closes bought Burden Mansion, a Beaux-Arts grand house on Fifth Avenue. The palatial home along the so-called "millionaires row" put the couple in the same social sphere as the Fricks, Vanderbilts, and Whitneys, who had all built homes on Fifth Avenue.

Burden Mansion's lavish French-style interiors marked a turning point in the evolution of Mrs. Post's aesthetics. Her Greenwich, Connecticut, home had been the essence of Victorian taste. Now, under the influence of Jules Allard, a French cabinet-maker who crossed the Atlantic to design fashionable French eighteenth-century-style interiors for wealthy Americans, Mrs. Post began to furnish her grand home with rare tapestries and French period furniture.

Lacking an art history background, she relied on the advice of Allard and French & Company, who shaped her taste in things French and European. Nobody, however, played a more critical role in helping her build her collection than the art dealer Sir Joseph Duveen who, in her own words, would remain, along with her father "the most influential man in my life." Rather than invest in the Old Master paintings Duveen hoped to sell her, she revealed a profound interest in the decorative arts.

Collecting decorative arts was not a new concept. For centuries European princes and wealthy merchants had acquired objects along with paintings. It was only in the nineteenth century that a serious chasm appeared separating the assessment of fine and decorative arts. At the turn of the twentieth century, J. P. Morgan

and Henry Clay Frick revived a tradition of mixing paintings and sculpture with decorative arts objects. Mrs. Post's collection differed from theirs in that it centered almost entirely on decorative arts and lacked great paintings.

In Mrs. Post's collection, paintings serve mostly as backdrops for elegantly appointed rooms. It is the furniture and objects that take center stage. Among her paintings the genre of portraiture predominates. She made one of her most important purchases of the 1920s when she acquired the *Portrait of the Duchess of Parma and her Daughter Isabelle* by Jean-Marc Nattier, a fashionable painter at the court of the French king Louis XV.

Mrs. Post turned her collector's eye first to tapestries. In the early 1920s, under Duveen's guidance, she attended classes on the subject at the Metropolitan Museum of Art. Soon thereafter she made her first significant purchases in this area. Among early textile acquisitions number the Beauvais tapestries of the *Italian Feasts* and the *Loves of the Gods* series, after designs by François Boucher; both are now at Hillwood. At the turn of the century, critics and collectors regarded tapestries as highly valuable works of art, much more so than is the case today. Frick, for example, paid more for tapestries than for any other furnishings, while Mrs. Post paid Duveen astronomical sums for her sets.

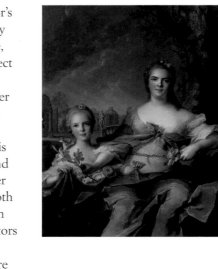

With the purchases of French period furnishings she made during the early 1920s, Mrs. Post carved a niche for herself among discerning collectors of European art. The Roentgen desk, a collaborative creation of cabinetmakers Abraham and David Roentgen, has traditionally appeared in the literature as a presentation piece made around 1774 for Marie Antoinette. Regardless of its provenance (still uncertain today) the desk figures as a highlight in Hillwood's collection and one of Mrs. Post's favorite acquisitions.

The period from the late 1920s to the mid-1930s was one of steady collecting of French decorative arts to fill the spaces of her brand new Manhattan penthouse apartment in a 1926 building. Of the pieces acquired at this time, the outstanding commode (see page 13) made by Jean-Henri Riesener, cabinetmaker to Louis XVI, had formerly belonged to Lord Hertford in Paris. Art dealer Jacques Seligman bought Lord Hertford's furnishings as a complete lot in 1912. While Frick

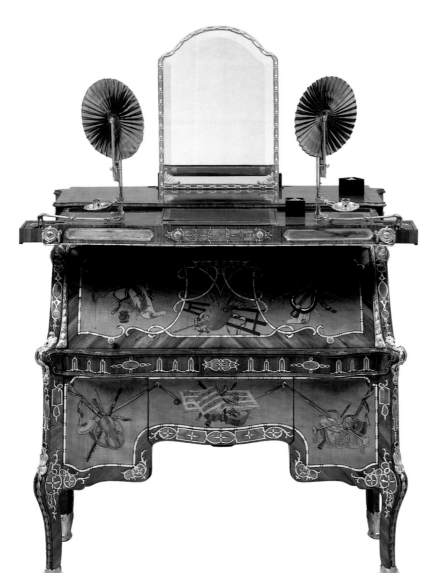

Above

Beauvais Tapestry, detail of
Les Fêtes Italiennes
Designed by François Boucher, 1736

Opposite top

*The Duchess of Parma and Her
Daughter Isabelle*
Jean-Marc Nattier, 1750

Opposite

Roll-top Desk
Abraham and David Roentgen
Neuwied, ca. 1770

acquired most of Lord Hertford's furniture through his interior decorator Elsie de Wolfe, Riesener's commode ended up with Duveen, from whom Mrs. Post bought it in 1931.

Like other collectors of her time, Mrs. Post developed a fondness for French gold boxes, which set the tone for her later purchases of works by the firms of Fabergé and even Cartier. The boxes epitomized her taste for the beautifully crafted and her affinity for precious metals and small objects that reflected both the civility and frivolity of the French court and aristocratic society prior to the Revolution of 1789.

In Mrs. Post's lifelong and relentless pursuit of adding treasures to her collection, she paid close attention to each individual purchase, rarely buying great numbers of items as a lot.

During the early years of her marriage to her second husband, Edward F. Hutton, which lasted from 1919 to 1935, her collection grew so much that at the instigation of Duveen she began preparation of a catalogue to be privately printed. Inspiration probably came from J.P. Morgan, who had published a limited-edition catalogue of his collections to give out to a few selected individuals. Undoubtedly, Mrs. Post followed Morgan's example as a way to solidify her reputation as a collector. Consultants began work on the catalogue, but the 1929 stock market crash spelled an end to the project.

In 1935 Mrs. Post divorced E.F. Hutton and married Joseph E. Davies, who a year later was appointed by President Franklin D. Roosevelt as ambassador to the Soviet Union. The Davies couple

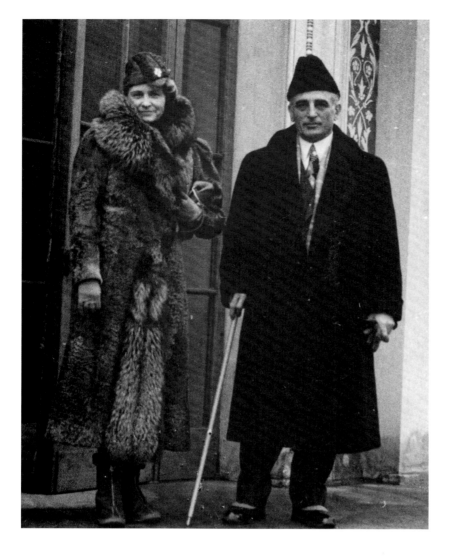

spent only eighteen months in Moscow, but this initial Russian experience was to have a profound impact on Mrs. Post and her future collecting activities. In purchasing Russian art, she moved into totally uncharted territory, with no Joseph Duveen to guide her. She had to rely on her own eye.

Mrs. Post did not go to Moscow armed to buy Russian art. At the time, she owned at least two objects by the Russian court jeweler, Carl Fabergé: one a small box (below) sold by Felix Iusupov at Cartier along with family jewels in the 1920s, the other the Catherine the Great Easter Egg, which Mrs. Post received from her daughter Eleanor as a gift in 1931. Both pieces more likely reflect her love for finely crafted French gold boxes than for their Fabergé pedigree.

In Joseph Davies Mrs. Post found the first husband who shared her collecting enthusiasm. The couple began collecting religious art—icons, liturgical silver, and textiles—at the end of a period when the Soviet govern-ment sought to finance industrial-ization at home and communist parties abroad by selling off its national treasures. Officials gave orders to melt down nineteenth-century objects, especially liturgical pieces, for their silver and gold content. Of stories related by Mrs. Post, more have to do with the acquisition of icons, chalices, and vestments than any other type of Russian purchase. Icons and chalices never fit into Mrs. Post's neoclassical decorating scheme, so already at Tregaron, the house where she and Davies lived in

Above

Mrs. Post and Ambassador Joseph E. Davies in Moscow, 1937

Left

Box, Firm of Carl Fabergé
St. Petersburg, 1886–96

Opposite top

Mrs. Post in the Icon Room at Tregaron, ca. 1950

Opposite

Pieces from the Orlov Service
Imperial Porcelain Factory
St. Petersburg, 1762–65

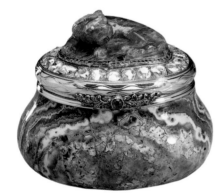

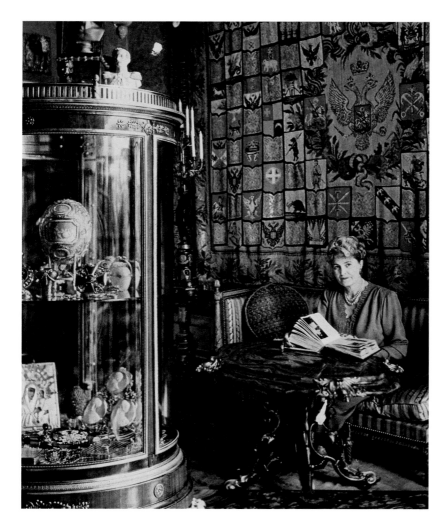

Washington, she created a special treasury or "icon room."

The Davies traveled extensively during their diplomatic tenure in Moscow. They spent the summer of 1937 on the *Sea Cloud*, Mrs. Post's yacht, sailing from one Baltic port to another on a special mission for President Roosevelt, but also conducting collecting excursions in their spare time. Once Mrs. Post caught the Russian fever, it gave new meaning to these shopping adventures. In the fall of 1937 Mrs. Post went to Vichy, France, where she found about twenty pieces of the famous Orlov porcelain service.

These pieces alone, however, do not account for the greatness of Hillwood's collection. They form a nucleus of only about a fifth of the museum's Russian collection.

Contrary to popular perceptions, Mrs. Post did not load up the *Sea Cloud* with all of Hillwood's Russian treasures and sail away. The Moscow experience merely provided the impetus that

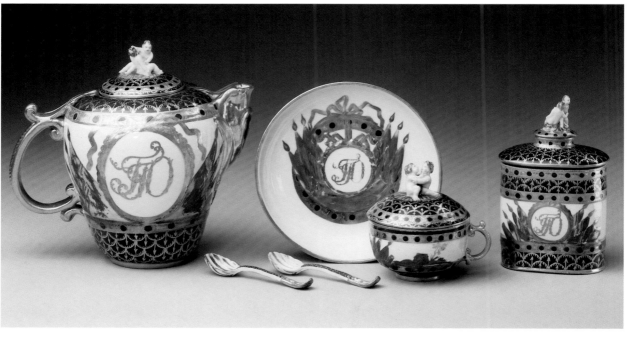

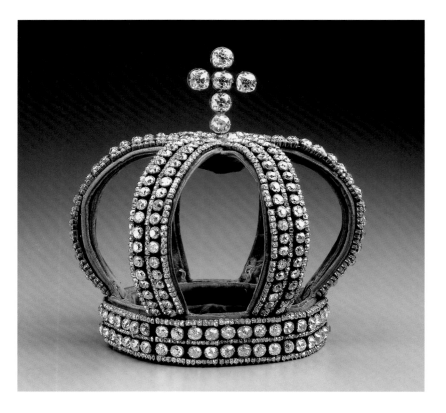

set her on a new collecting path. She collected Russian art for the rest of her life, buying many things that had left the Soviet Union decades before. Indeed, many of her Russian purchases in the late 1960s had, in fact, left the Soviet Union in the 1920s. The Soviet authorities sold the imperial wedding crown worn by Alexandra at her wedding to Nicholas II at auction at Christie's in London in 1927. Mrs. Post acquired it in 1966. That same year she purchased the first of two outstanding gold chalices. In 1968 she bought the Buch chalice that Catherine had commissioned as part of a liturgical set for the Aleksandr Nevskii Monastery in St. Petersburg.

In 1955 Mrs. Post bought Hillwood, a 25-acre property with a mansion built in the 1920s. She spent two years renovating the house, with French & Co. advising her in the design of spaces to serve both as a residence and as a show-case for her collection. By 1952 she had already conceived the idea of making her house a museum. Like other collectors with a democratic spirit, she believed that as she had enjoyed the fruits of the capitalist system, she should give back to society what she had been able to collect with the wealth she had inherited and earned.

Hillwood blends the two main interests of Mrs. Post as a collector. In the foreword to the museum's first guide, she eloquently expressed what those were: "My two major interests have been the art of 18th century France and that of Imperial Russia. . . . French 18th century art was my earlier interest and the Russian collection only started when I was *en poste* in Russia. . . . As the influence of French artists and artisans was very strong in old Saint Petersburg and Moscow, it seems quite natural that these two artistic expressions should be brought together here."

By the 1950s Mrs. Post was a recognized collector of Russian art. She received a steady flow of letters and photographs offering her one object after another. It must have been a special pleasure to find a treasure that combined her two loves: a French gold box with a portrait of Catherine in the guise of Minerva. By 1958 Mrs. Post's Russian collection had grown sufficiently so that she hired Marvin Ross to catalogue it. Ross, a Harvard trained art historian with a background in Byzantine and medieval art, implemented standard museum practices at Hillwood: he created object files, oversaw the conservation of the collection, devoted his time to research and publication, and advised Mrs. Post on acquisitions.

In 1964 Ross was at work on his book *The Art of Karl Fabergé and His Contemporaries* (1965). It is clear that his research led him to suggest more Fabergé objects to Mrs. Post, and she bought at least six pieces in 1964 and at least twenty between 1964 and 1969. One of the most important of these later items is the Iusupov music box, purchased from the estate of Lansdale K. Christie in 1966. Ross

rightly called it a "true museum piece–and historic" when he successfully convinced her to pay the asking price.

By 1965 Mrs. Post had opened negotiations with the Smithsonian Institution about donating her house and collection. In 1968 she made this offer formally; it was accepted in January 1969. From then on a number of objects and paintings entered the collection as gifts to the Smithsonian to be housed at Hillwood. Mrs. Post herself gave the painting *The Countess Samoilova and Her Foster Daughter* (see page 23) by Karl Briullov in this manner. The Smithsonian never opened Hillwood to the public and in 1976 decided to return it to the Foundation, which administers Hillwood Museum and Gardens.

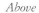

Above

Music Box
Firm of Carl Fabergé
St. Petersburg, 1907

Top

Top of Music Box

Below

Marvin Ross with students in the Hillwood French Drawing Room, 1960s

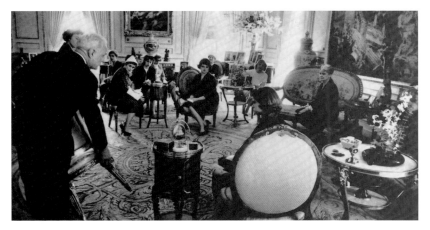

Hillwood Museum opened to the public in 1977, fulfilling Mrs. Post's wish to make her collection available for the enjoyment and edification of future generations. A pioneer collector in the Russian field, she has provided Americans with an opportunity to experience Russian imperial art in a historical context that provides insights into its character. Hillwood's French collection makes possible comparisons of Russian with French objects, demonstrating the enormous sway French art had on Russian artists and patrons. In addition, Hillwood affords visitors the chance to see Mrs. Post's collections in a refined domestic setting, one which in scale and scope reflects that of the original owner's intentions.

Left

Ice Cup from the Cameo Service
Sèvres, ca. 1778/1779

Opposite

Countess Samoilova and Her Foster Daughter
Karl Briullov, ca. 1840s

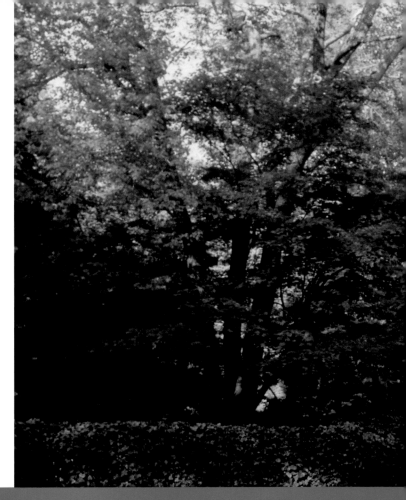

A Tour of the Estate

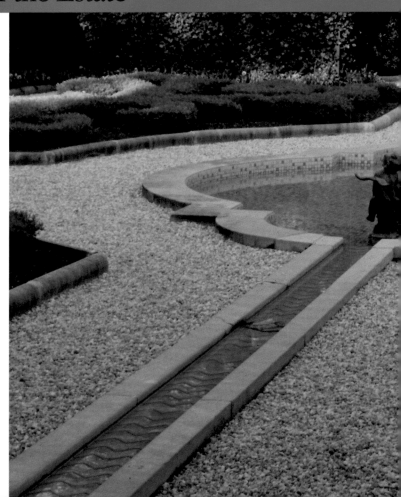

View of the French Parterre

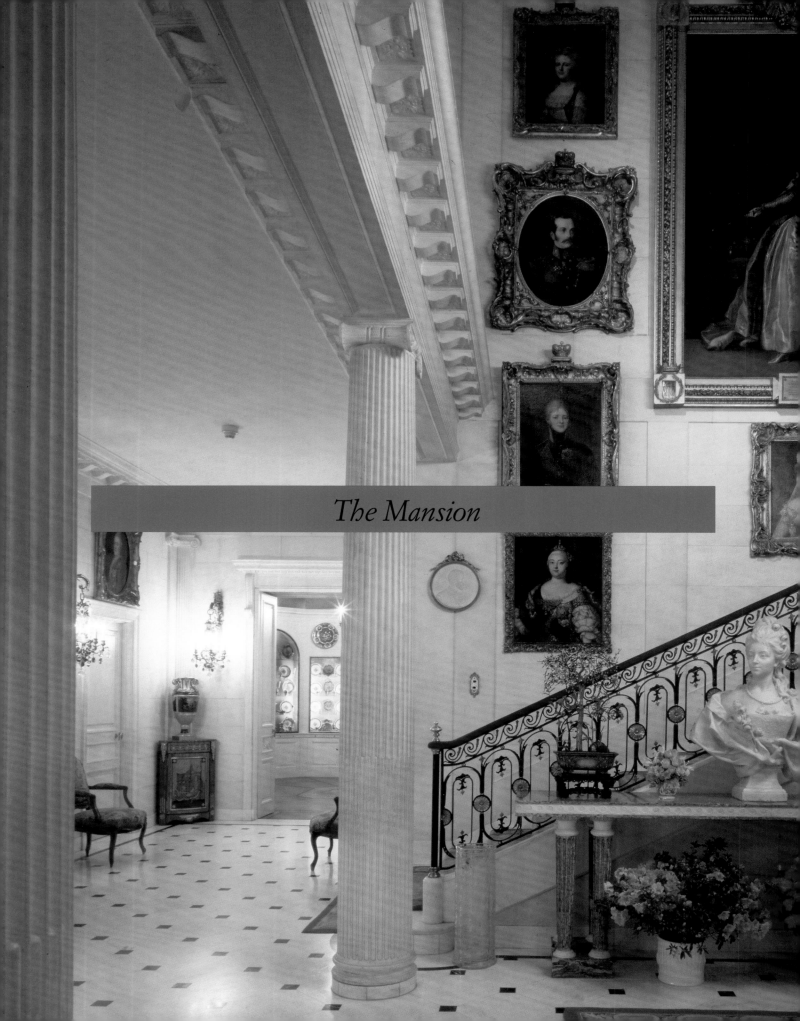

The Mansion

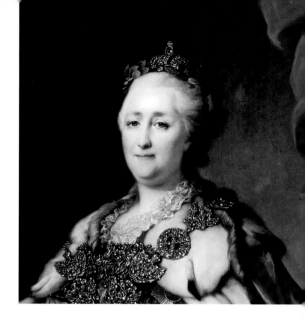

Hillwood, Marjorie Merriweather Post's residence in the heart of Washington, was conceived both as a home and a museum to showcase her collection of Russian and Western European decorative arts.

Mrs. Post bought the Hillwood property in 1955 following her divorce from Joseph E. Davies. She spent two years renovating the mansion, a 1920s neo-Georgian-style house, and named it after the residence she once owned on Long Island. Having already decided that her home would be a museum, she made sure renovations satisfied her style of living and entertaining and guaranteed that future generations of the public would enjoy her collections. Alterations to the mansion included providing a third story by raising the roof, adding the pavilion wing, and enlarging the kitchen at the east end of the house. Today's visitors, like Mrs. Post's guests, enter her home through the motor court into the Entry Hall.

Above

Detail of *Portrait of Catherine II* (see page 84)

Left

Mansion Entry Hall

Entry Hall

A tour of Hillwood begins in the grand reception hall faced with plaster simulating a limestone called Caen stone. The Entry Hall boasts a distinct mix of Russian and French fine and decorative arts—Mrs. Post's two main collecting interests. Standing under a large Louis XV chandelier made of rock crystal with gilt bronze mounts, visitors encounter portraits of Russian emperors and empresses from Peter the Great to Nicholas II displayed high on the wall above the staircase. Dominating this group of paintings, a large parade portrait of Catherine the Great had been a gift of Catherine to her banker Henry Hope of Amsterdam around 1788 for his help in securing financing for Russia's Turkish wars.

The spaciousness of the Entry Hall makes it well suited for the display of several large commodes, or roomy chests of drawers, and palace sized vases. Two commodes attributed to Henri Riesener, the

great French cabinetmaker to French King Louis XV, flank the door going into the library. Both splendidly display Riesener's skill at marquetry, the fitting together of many pieces of wood to make elaborate pictures or geometric compositions. A pair of Russian porcelain vases from the reign of Nicholas I sit on top of each of these commodes.

Above

Leaf-Shaped Dish
Frances Gardner Factory
St. Petersburg, 1777–1800

Russian Porcelain Room

Mrs. Post's particular love of porcelain is immediately apparent from the amount of display space she devoted to it. Interior designers planned the Russian Porcelain Room according to a decorative scheme similar to ones architects and designers had adopted in the past to integrate the display of porcelain with a room's layout and furnishings. Here, eight wall cases contain so-called order services commissioned by Catherine the Great in the late 1770s. Knights of the various orders honored for their government and military service used these services when they dined at the Winter Palace on the feast day of their patron saint.

Pavilion

Mrs. Post conceived the Pavilion as a space for after-dinner entertainment—usually first-run movies. Behind the balcony a 1950s' state-of-the-art projector showed movies on a screen that drops from the ceiling over the piano at the other end of the room. Occasionally the room accommodated square dancing; to protect the elaborate eighteenth-century floor, ladies had to wear rubber tips on their fashionable high heels.

Two large paintings that came into the collection in the late 1960s dominate the room: on one side *The Countess Samoilova and Her Foster Daughter* by Karl Briullov, painted in the 1840s; and on the other, in stark contrast to the very Western theme of the countess *A Boyar Wedding Feast* by Konstantin Makovskii. It depicts the presentation of roast swan at a wedding banquet in the seventeenth century, before Peter the Great's Westernization reforms.

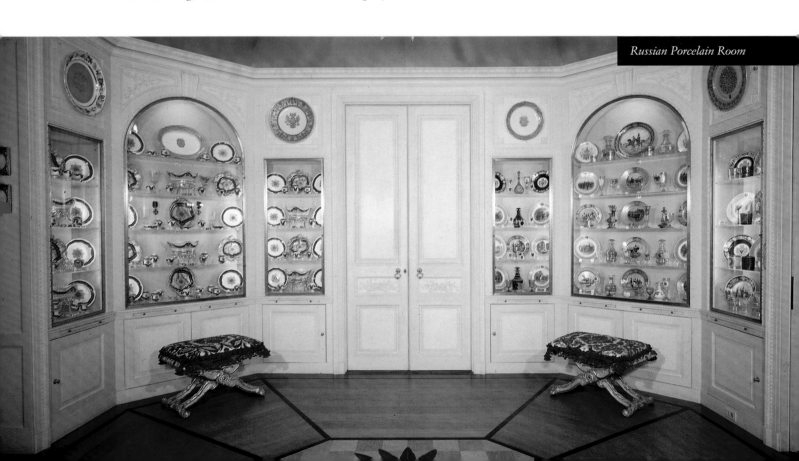

Russian Porcelain Room

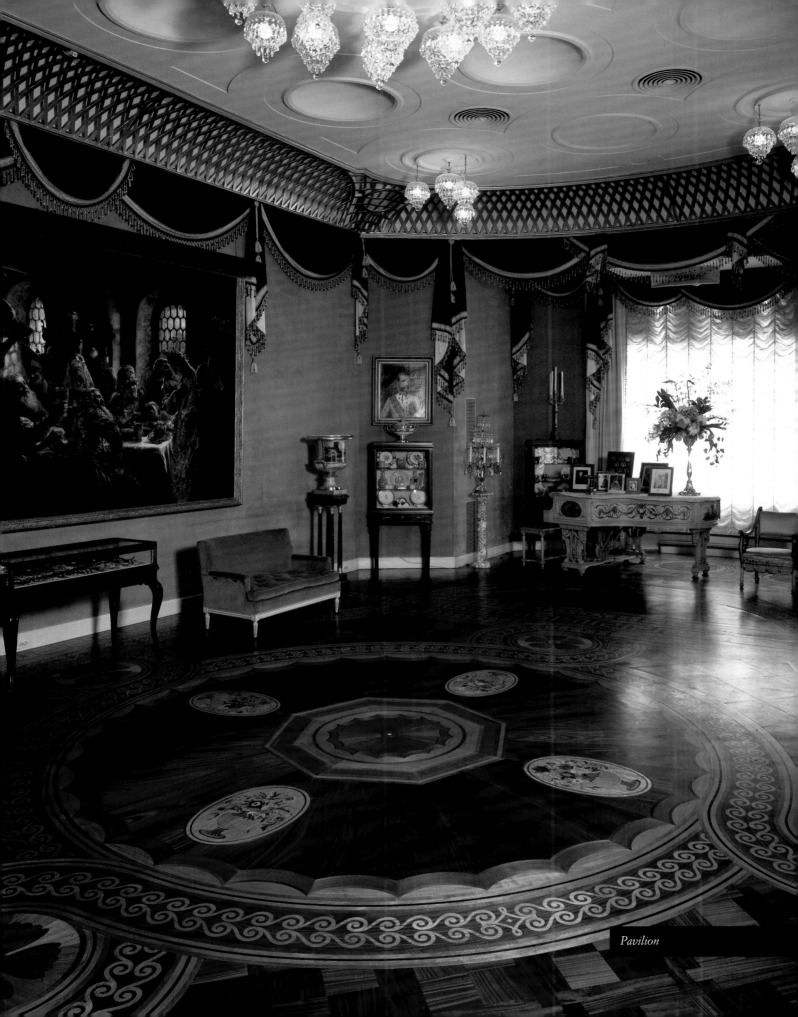

Pavilion

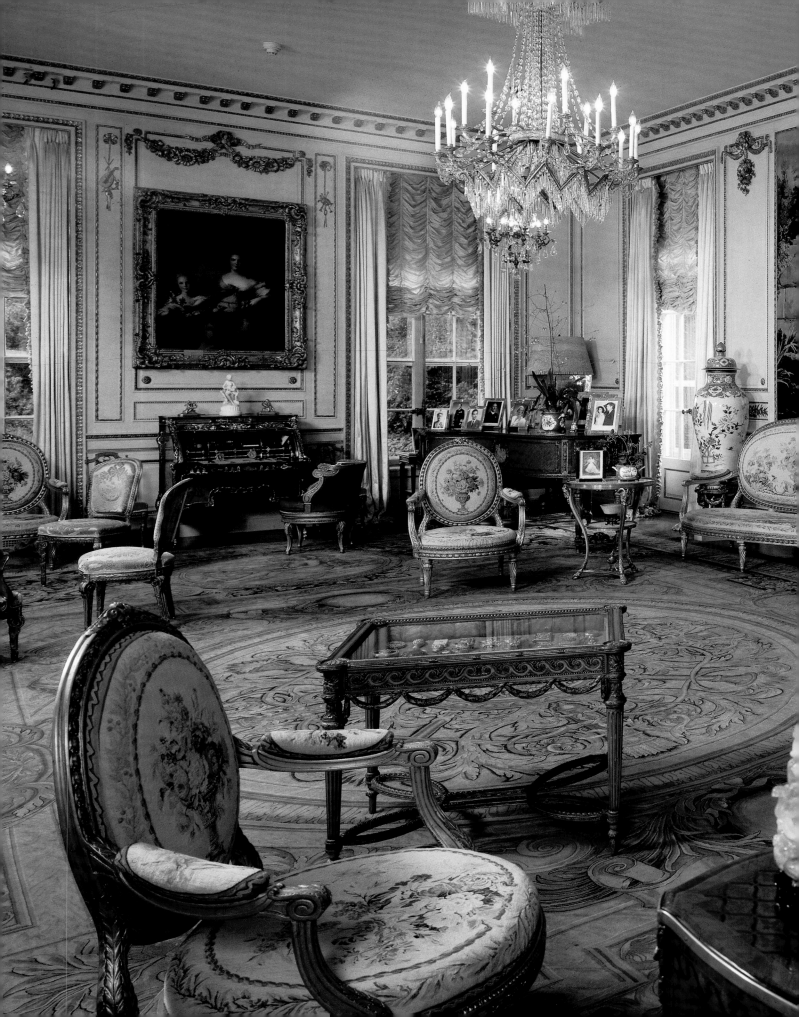

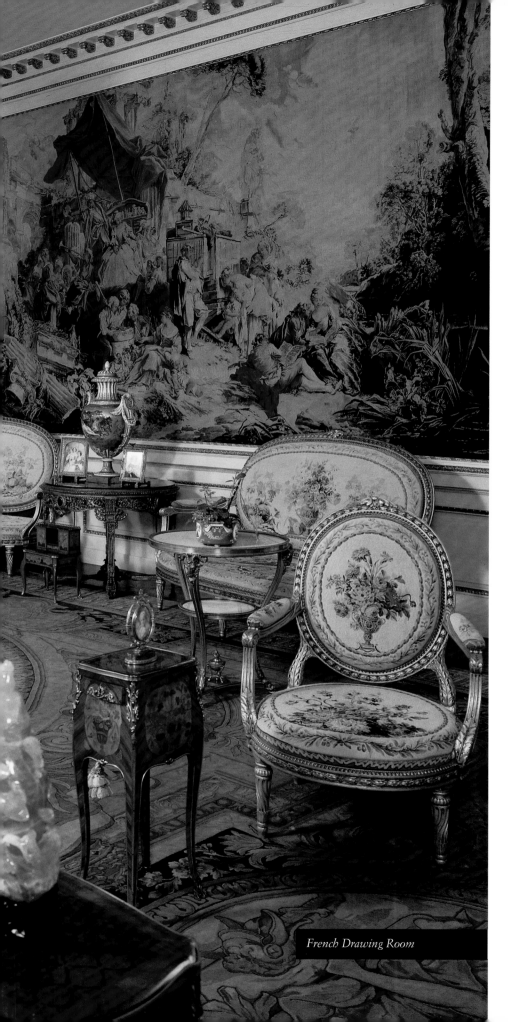

French Drawing Room

Mrs. Post greeted dinner guests in the Louis XVI-style Drawing Room. In nice weather they could walk out into the French garden through doors on the far side of the room. The Drawing Room reflects the concept of a "period room," popular in many historical museums across America. Here, a domestic space rather than a generic exhibit gallery showcases art collections to their best advantage. The Drawing Room's furnishings represent Mrs. Post's earliest collecting interests. In the 1920s, under the tutelage of Sir Joseph Duveen, she began acquiring outstanding examples of French decorative arts. From Duveen she purchased the three Beauvais tapestries (after designs by François Boucher) that hang here—the large one of *The Italian Feasts* and two smaller ones, *Jupiter and Antiope* and *Bacchus and Ariadne*, both from the series The Loves of the Gods.

The magnificent roll-top desk by Abraham and David Roentgen and Jean-Marc Nattier's portrait above of the Duchess of Parma and her daughter entered Mrs. Post's collection in the 1920s. The desk, a masterpiece of eighteenth-century marquetry with inlaid mother-of-pearl, depicts allegorical images of the arts and sciences in vari-colored woods. A tour-de-force in its mechanical devices, the desk contains more than forty secret compartments.

Both the Nattier portrait and *Empress Eugénie* by Franz Winterhalter on the wall over the fireplace exhibit Mrs. Post's eagerness to acquire art objects

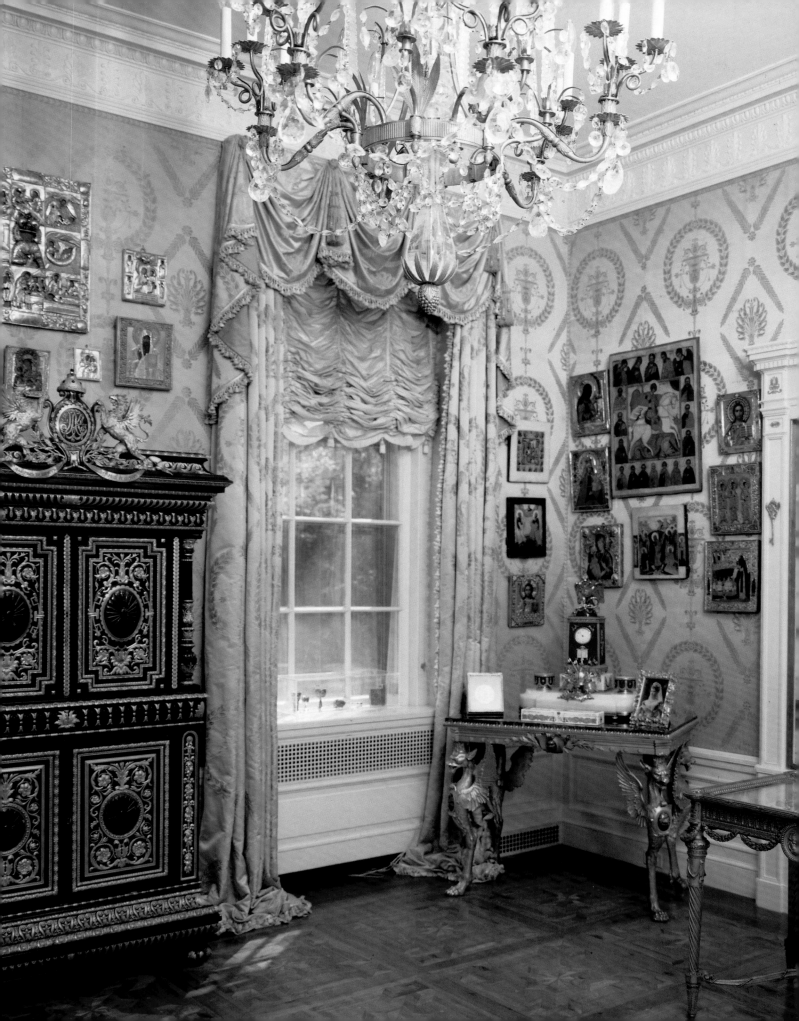

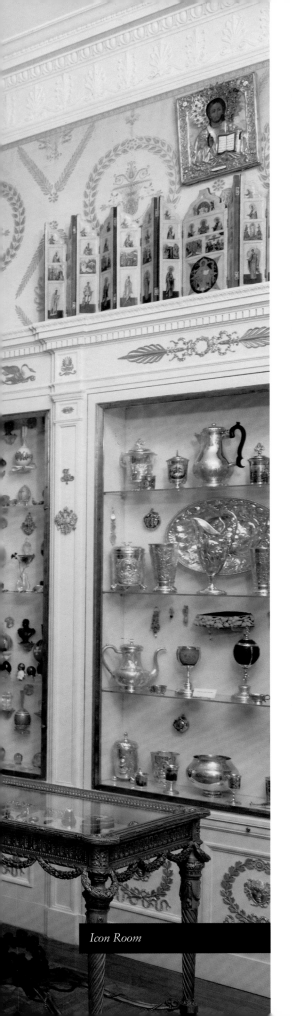

Icon Room

with royal or historical associations, a fascination already hinted at by the portraits of Russian rulers in the Entry Hall.

The Western European gold boxes displayed in a table vitrine demonstrate Mrs. Post's love for small, beautifully crafted precious objects. Highlights include a shell-shaped box decorated with enameled flowers on a mother-of-pearl surface mounted on gold. Such boxes served as gifts to diplomats and loyal servants of the state as well as personal friends. Many originally contained snuff, a popular form of tobacco in the eighteenth century.

Icon Room

Mrs. Post realized that the display of Russian gold and silver objects, especially liturgical plate and icons, required a special place, a kind of treasury, which she called her Icon Room. For the most part, the icons on display here are of the type purchased by Russian individuals for worship at home; they are not church icons. Many feature elaborate covers, called *oklady*, made of silver with decorations of enamel or niello. Mrs. Post's interest in icons dates to the time she lived in Moscow in the late 1930s as wife of the American ambassador, Joseph E. Davies.

The silver displayed in this room covers a period from the late seventeenth century to the magnificent creations made by the Russian court jeweler, Carl

Right

Detail of
Catherine the Great Easter Egg
(see page 97)

Fabergé. Mrs. Post experienced the delight of discovering that some tarnished chalices she thought were pewter actually were silver-gilt. She succeeded in purchasing them for approximately five cents per gram weight because the Soviet authorities had no interest in such objects beyond melting them down for their metal value.

No type of Russian art surpasses the works of Fabergé in terms of popularity and fame. Hillwood's approximately eighty pieces made by the Fabergé firm include two imperial Easter eggs, both gifts from Nicholas II to his mother, Maria Fedorovna. He gave her the Twelve Monogram Egg in 1895, the first Easter after the death of his father, Alexander III. Maria later received the Catherine the Great Easter Egg in 1914. Other major Fabergé works are a music box commissioned by the two Iusupov brothers for their parents' twenty-fifth wedding anniversary and a rococo-style clock, a gift from Nicholas and Alexandra to the Dowager Empress Maria Fedorovna. As with many other items in her collection, Mrs. Post favored works by Fabergé with ties to the imperial family, either as gifts received or bestowed.

A powerful reminder of the last imperial family, the crown worn by

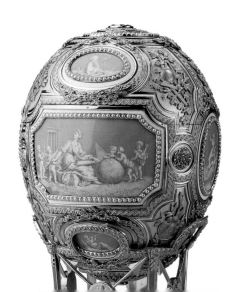

the Empress Alexandra when she married Nicholas II in 1894 made use of diamonds that once belonged to the Emperor Paul. The small crown sat on the top of the Empress' head behind a small *kokoshnik*, or Russian-style tiara. The Soviet authorities auctioned the crown at Christie's in London in 1927, but Mrs. Post did not purchase it until 1966.

First Floor Library

The English-style library, paneled with eighteenth-century pine carved in England, provided Mrs. Post with a comfortable setting to entertain a few friends or family in front of a fire. Here, she added favorite personal memorabilia to her museum-quality objects: over the fireplace a portrait of her father, C.W. Post and at the other end of the room, a portrait of her mother, Ella Merriweather Post. Family photographs and miniatures feature frames by Cartier and the American firm of Caldwell.

Above

Frame with Miniature of Mrs. Post and Her Daughter Nedenia
Firm of Cartier
New York, 1928

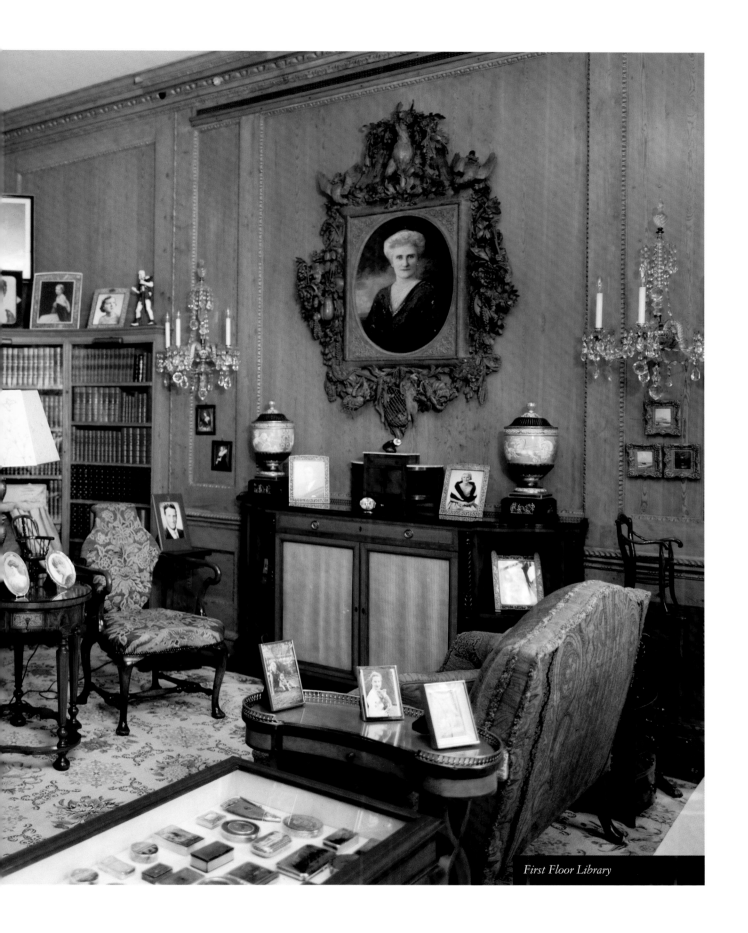

First Floor Library

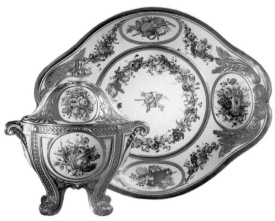

Dining Room

The Dining Room functioned as the center of much of Mrs. Post's entertaining. The room boasts a set of French Regency carved oak panels, originally part of the salon of the Harjes family mansion in Paris. Modern sections have been added to fit the size of the room. Four large paintings depicting hunting scenes by the eighteenth-century Dutch artist Dirk Langendijk hang on the walls. The nineteenth-century Aubusson carpet was a gift from Napoleon III to Emperor Maximillian of Mexico.

Mrs. Post commissioned the table with its ornate hardstone mosaic top from the artisans of the Opificio delle Pietre Dure (Factory of Hard Stone) in Florence in 1927 for her Palm Beach home, Mar-a-Lago. The architect Joseph Urban helped with the design and supervised the commission. In constant use at Mar-a-Lago, the table came to

Above

Soup Tureen and Platter
Sèvres, ca. 1783

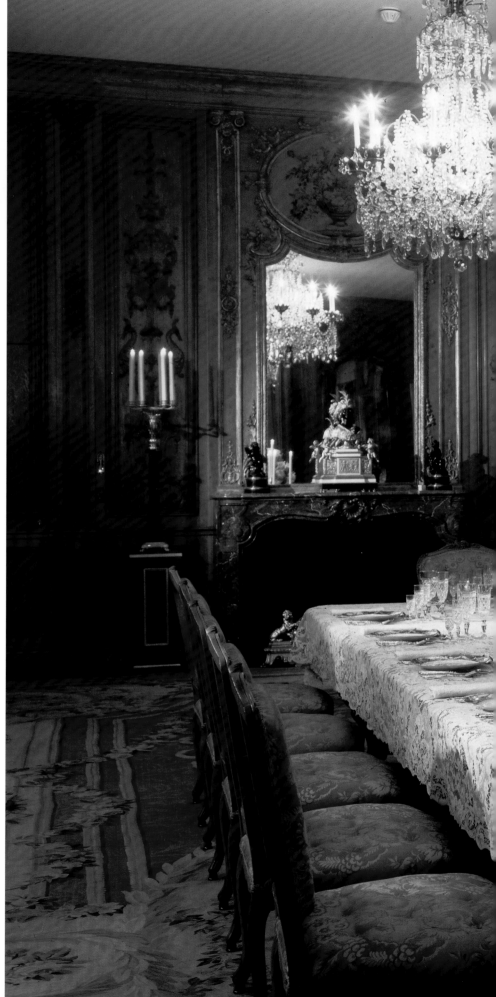

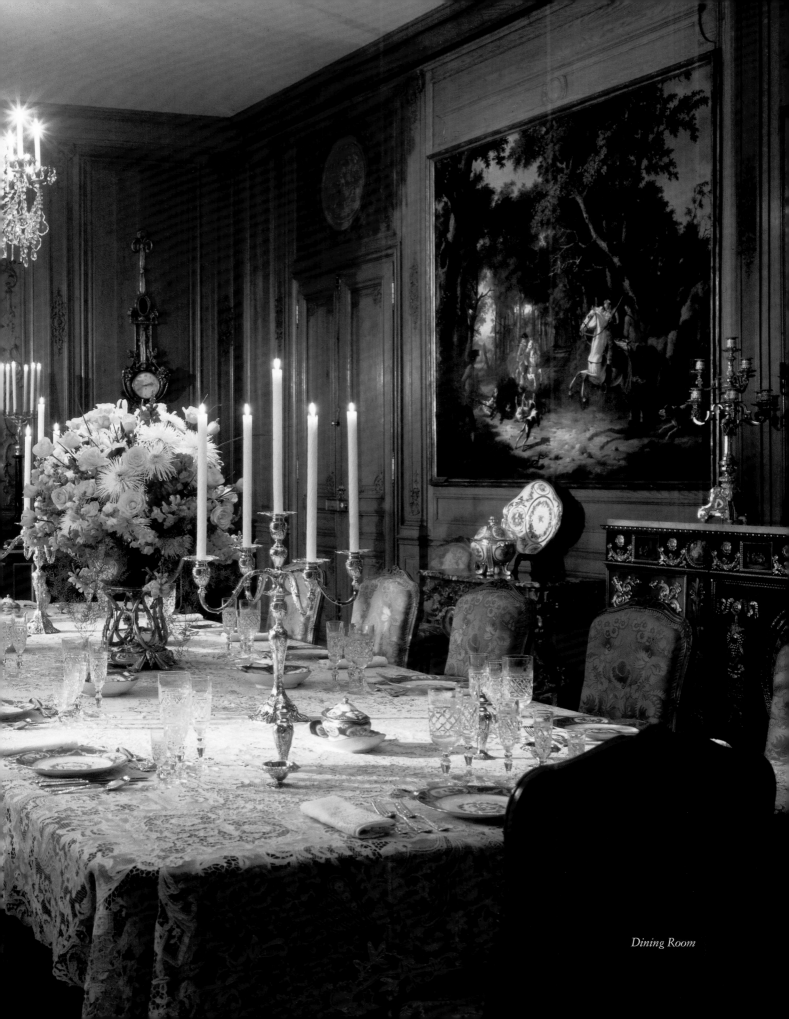

Dining Room

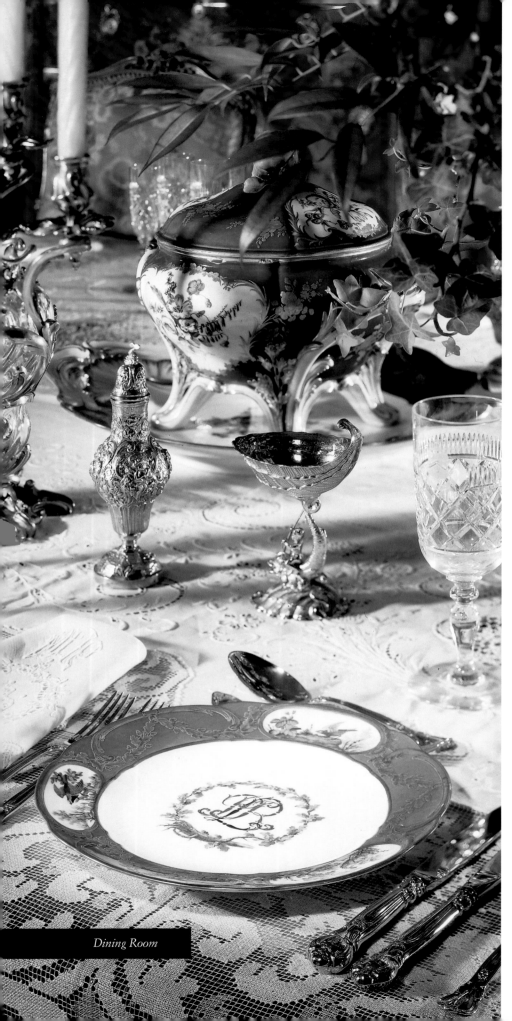

Hillwood after Mrs. Post's death according to the dictates of her will. The table settings change regularly, so repeat visitors can see different examples of porcelain and glass. She and her guests often dined on eighteenth-century Sèvres, the Russian order services, or other Russian porcelain, as well as twentieth-century English wares.

Breakfast Room

Facing south and filled with flowering plants, the wonderfully cheerful Breakfast Room looks out into the garden. The tables here and in the Dining Room are always set with fresh flowers. Although called a Breakfast Room, Mrs. Post frequently had lunch here with her secretary or a couple of friends.

The room's highlight is the chandelier of green and clear glass with gilt bronze mounts. Charles Cameron designed it, probably for one of the bedrooms at the Catherine Palace, a summer residence in the town of Tsarskoe Selo outside St. Petersburg, which Cameron redecorated for Catherine the Great.

Above

Compote from the South American Bird Service
Sèvres, 1819–21

Dining Room

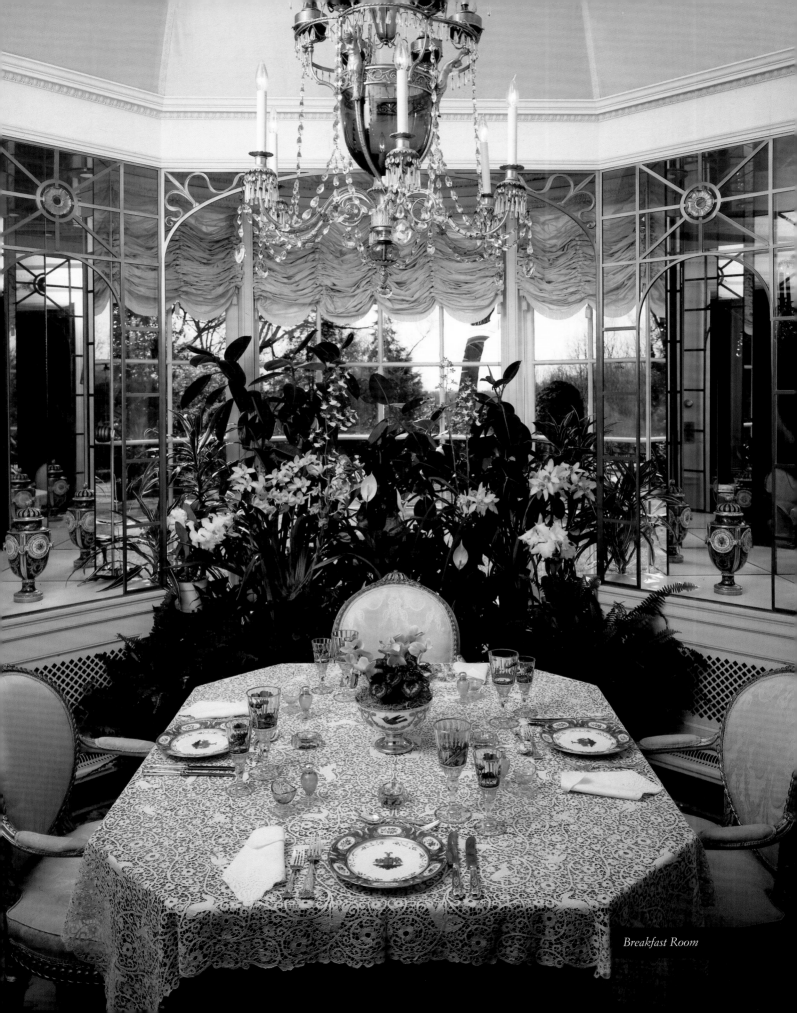

Breakfast Room

French Porcelain Room

Mrs. Post began purchasing Sèvres porcelain in the 1920s and retained a lifelong love for turquoise blue, or *bleu celeste*. She acquired Sèvres porcelain both for display and for use on her table. An outstanding tureen and platter in the rococo style dates from 1754. Other pieces of note include a cup and saucer with a portrait of Benjamin Franklin, who served as American minister to Paris in the 1770s and, nearby, a pair of cups decorated with a *rebus*, or a word and picture puzzle, on a yellow ground.

Pantry and Kitchen

Mrs. Post stored pieces of porcelain and glass in the pantry, where some are still on display. The pantry conveniently connects the dining room to the spacious 1950s-style kitchen with a large restaurant stove. The freezers recall the fact that Mrs. Post was an early advocate of frozen food, having encouraged her second husband E.F. Hutton to buy out Birdseye. Mrs. Post's house staff of approximately thirty to thirty-five people included two cooks and two helpers.

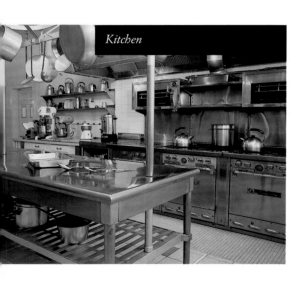

Kitchen

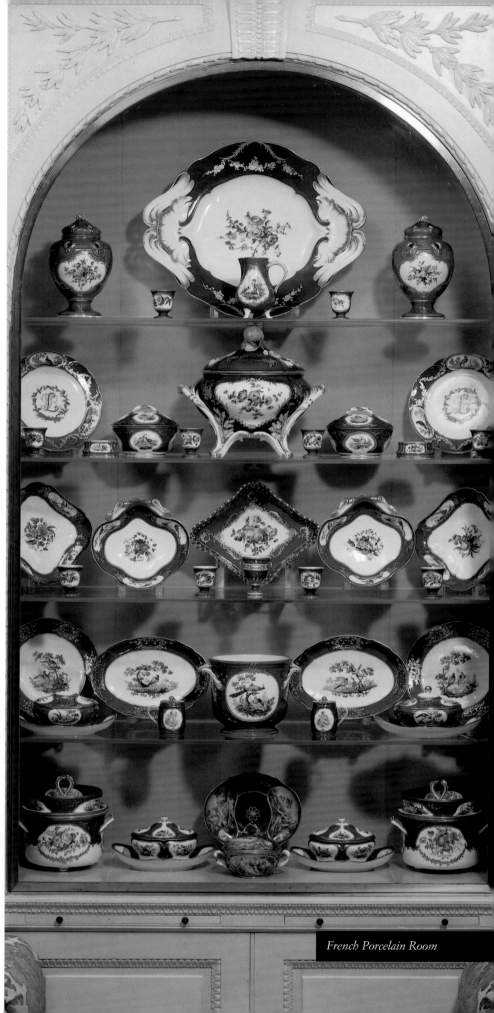

French Porcelain Room

Russian Liturgical Gallery

Off the kitchen, in the former staff dining room, an exhibition gallery displays a number of icons, vestments, and the splendid gold chalice Catherine the Great commissioned as part of a communion set in 1792 for the Aleksandr Nevskii Monastery in St. Petersburg. During her stay in Moscow, Mrs. Post found the vestments stacked in heaps in local commission shops. Soviet authorities were burning them for their silver and gold thread.

Some of the most important icons at Hillwood include a pair of Tsar's or Royal Doors from a sixteenth-century *iconostasis,* or icon screen that separated the congregation from the sanctuary. Priests used these doors to enter the sanctuary during the liturgy.

Right

Royal Doors, Russia, 16th century

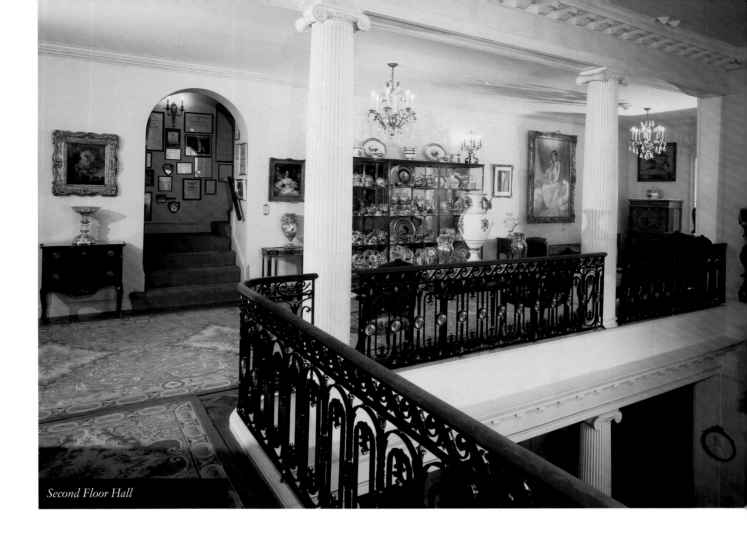

Second Floor Hall

Second Floor Hall

At the top of the stairs, a portrait of Princess Ekaterina Dashkova is signed by the eighteenth-century portrait painter, Dmitrii Levitskii. Dashkova took part in the coup led by the five Orlov brothers (of whom Grigorii was Catherine's favorite) that placed Catherine on the Russian throne in 1762. The cabinet just below the portrait features items from a service of early Russian porcelain that Catherine presented Grigorii Orlov shortly after the successful coup.

En route to Mrs. Post's bedroom, visitors pass a large standing glass case with porcelain from many of Russia's private factories, which produced wares for the gentry and the ever-expanding ranks of the middle classes in nineteenth-century Russia. Further along is a portrait of Mrs. Post with her third daughter, Nedenia Hutton (the actress Dina Merrill), as a young girl. Mrs. Post wears a Cartier emerald brooch that is occasionally on view in the jewelry display off Mrs. Post's dressing room. Appropriately, Marguerite Gérard's painting, *L'Enfant Chéri*, welcomes visitors to the house's more private realm. The painting embodies the nurturing and loving aspects of motherhood as conceived by the Enlightenment at the end of the eighteenth century. It also is a rare example of the work of a woman painter, the sister-in-law and pupil of French artist Jean-Honoré Fragonard.

Mrs. Post's Bedroom Suite

Mrs. Post's bedroom displays her favorite Louis XVI style of decoration. Her portrait by Douglas Chandor over the fireplace was placed there after her death. Chandor unfortunately died before completing the work, so the hands for which he was famous have not been finished.

The desk veneered in mahogany and decorated with gilt bronze

mounts came from the workshop of Conrad Mauter—one of the many German cabinetmakers who came to Paris during the eighteenth century. It displays a more pronounced neoclassical style than the transitional Roentgen desk in the French Drawing Room. Over the dressing table is a pastel of Mrs. Post's two older daughters, Adelaide and Eleanor, by the society painter, Pierre Tartoué. Mrs. Post also kept a table display of *étuis*—small cases to carry sewing or toilet articles—snuff boxes, and other containers made of bloodstone, her birthstone.

Mrs. Post's day began in her dressing room, where she breakfasted, went over the day's menus with her butler, and discussed her

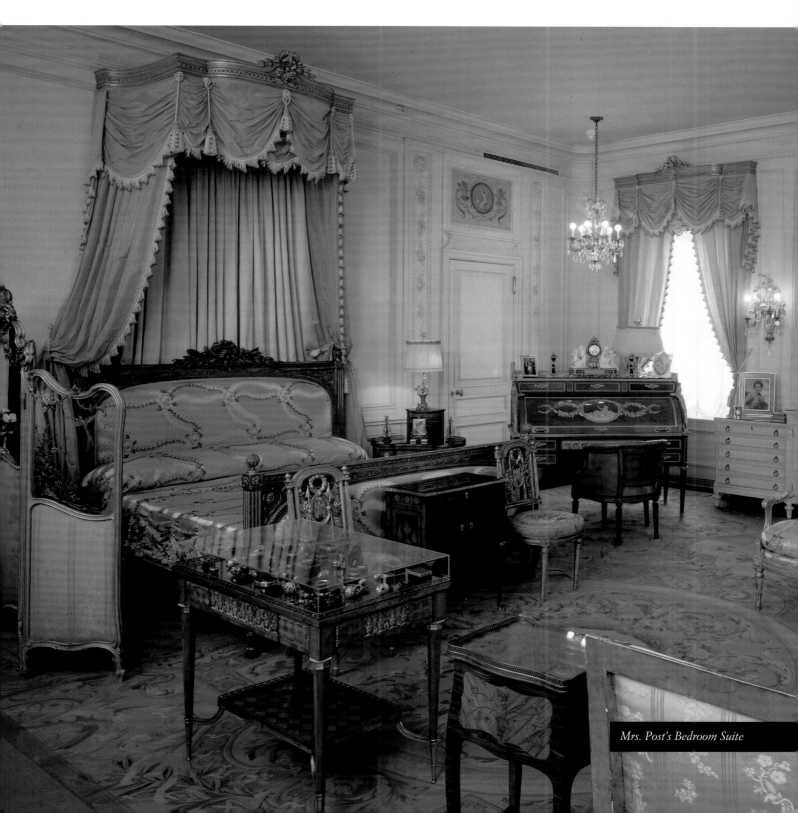

Mrs. Post's Bedroom Suite

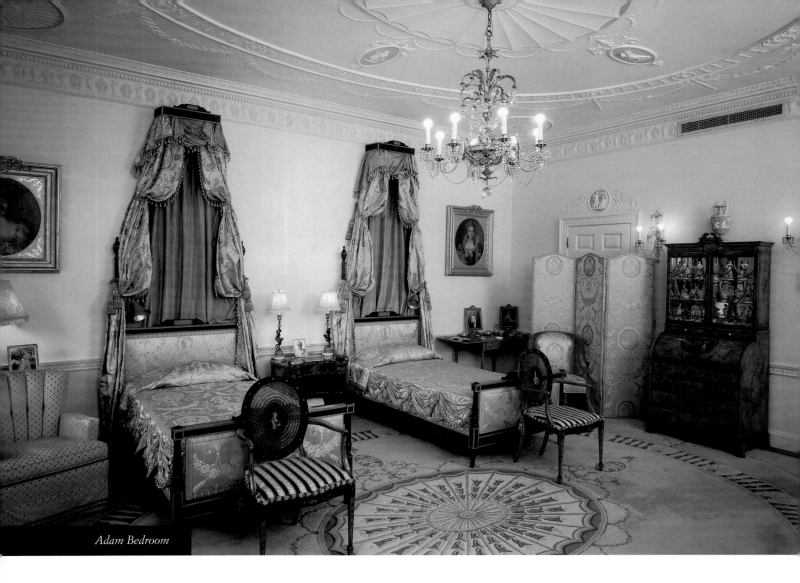

Adam Bedroom

correspondence with her secretary. Here, surrounded by family photographs, she enjoyed the splendid views out the bay window to the French Parterre below.

The hall off the dressing room has been slightly altered in order to better display some of her jewelry and shoes and to give visitors a clearer view into two of her closets where several of her dresses can be seen. There are about 180 dresses in the collection, some of which are rotated on a regular basis.

Above

Ice Pail
Wedgwood Factory
Stoke-on-Trent, ca. 1790

Adam Bedroom

The second floor contains two guest bedrooms. The Adam Bedroom reflects the so-called "Adam style," a version of neo-classicism popular in England in the eighteenth century. In this room the rug pattern matches the plasterwork on the ceiling. The room is furnished with Adam-style revival pieces made during the later Edwardian period. Several pieces of Wedgwood jasperware on the mantelpiece and cabinets containing English figurines complete the English classical

treatment of this room. The other bedroom, on view during "behind the scenes" tours, features English decor with Chippendale-style furniture and "sailors' wools," or embroideries fashioned by sailors at sea, framed and hung on the wall.

Second Floor Library

Because all the bedrooms are, in fact, suites, this library once served as a sitting room off the Adam Bedroom, with comfortable chairs making for a cozy atmosphere. Like the library downstairs, the furniture is English, including a fine Chippendale gaming table with its original needlework.

Above

Blue John Vase
Birmingham, ca. 1770–80

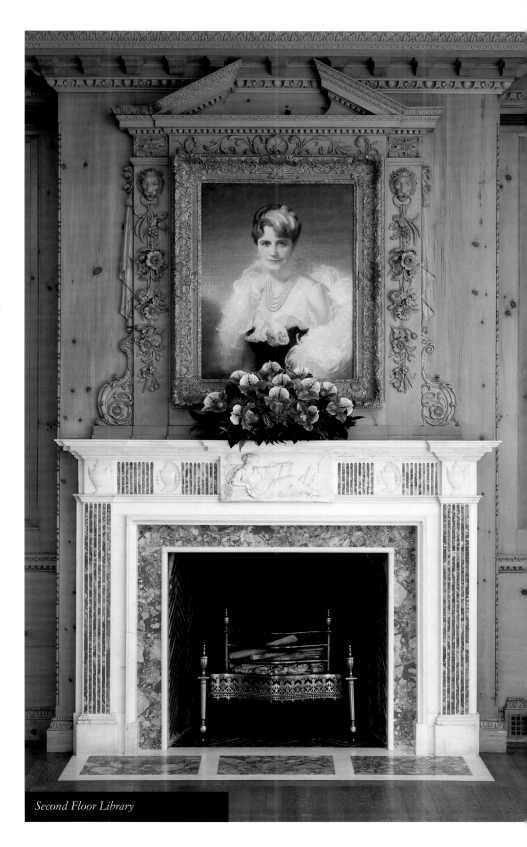

Second Floor Library

The Gardens and Auxiliary Buildings

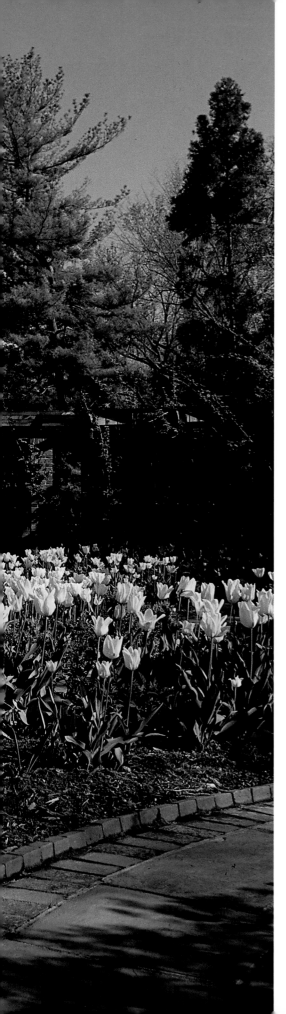

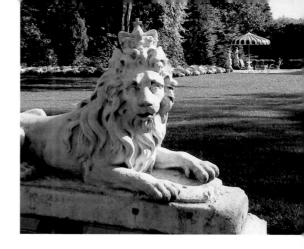

From the late 1800s to the beginning of World War II, wealthy Americans seeking to emulate English landed gentry built grand estates in the countryside. They constructed large houses of varying architectural styles on extensive and carefully landscaped properties to provide welcome relief from crowded urban conditions. There, amid greenery and fresh air, rich Americans could play tennis and golf, ride horses, and plan elaborate parties. The young Marjorie Merriweather Post refined her taste while this estate style held sway among her contemporaries.

Left

Rose Garden

Above

Lunar Lawn

I n 1926, Mrs. Post built her first estate on Long Island's gold coast, called it Hillwood, and hired landscape architect Marian Cruger Coffin to help her design and build an elegant estate according to the current fashion.

In 1955, while looking for a new home in Washington D.C., Mrs. Post visited an estate owned by Colonel and Mrs. Henry P. Erwin. Built in 1926, this twenty-five-acre property echoed the style of estate-building Mrs. Post had used in fashioning her Hillwood home on Long Island as well as her first Washington, D.C. residence, Tregaron. After purchasing the estate from the Erwins, she changed its name to Hillwood and began renovations to the mansion, gardens, and grounds.

Although the country estate fashion ended with the onset of World War II, Mrs. Post retained that style at Hillwood. Captivated by the beauty of the existing landscape created by the Erwins' architects, Mrs. Post incorporated extant features into her Hillwood renovations. Typical of the American country house tradition, Mrs. Post refurbished the mansion with porches and terraces on all sides to provide easy access to the vast grounds. She introduced new

passageways that connected the house to the garden walks, walls, and patios designed by the Erwins' landscape architect Willard Gebhart. Mrs. Post also chose to save some of the garden features and plantings designed by Rose Ishbel Greeley, a distinguished Washington, D.C.-based landscape architect.

To assist her, Mrs. Post retained the services of Umberto Innocenti and Richard Webel, two prominent landscape architects from Long Island. With their help, she created pleasure gardens for her own leisure and the entertainment of her guests. Innocenti and Webel planned a series of outdoor spaces that complemented the mansion's indoor spaces from which they radiate. They expanded the existing gardens to create a progression of outdoor rooms that are both separate and private, yet joined by winding paths. Each garden adopts an earlier historical style popular in eighteenth- and nineteenth-century Europe; the overall setting evokes an English park. Innocenti and Webel also added a long, winding entrance drive through terraced

beds and an enclosed motor court at the mansion's entrance.

Mrs. Post employed nearly thirty gardeners to plant mature trees and shrubs throughout the estate. Her newly planted gardens looked as if they had been established decades earlier, giving a sense of age and scale appropriate to the mansion and its landscape. Because Mrs. Post resided at Hillwood during the spring and autumn months, she filled the gardens with spring- and fall-flowering plants to blend with the surrounding woodland for the fullest effect during those seasons.

Moreover, Mrs. Post had extensive beds built and planted under established shade trees. Flowering cherries, crabapples, magnolias, and dogwoods bloom in concert with azaleas, spirea, and rhododendron that last from April into June. The riot of spring color provided by the trees and shrubs is accented by plantings along the walks of tulips, daffodils, primroses, pansies, and forget-me-nots. In September, chrysanthemums fill the beds and borders to accentuate the blaze of colors from the

hardwood trees in the gardens and surrounding woods.

Mrs. Post also brought the beauty of the garden indoors, filling every room in her home with fresh flowers from the gardens, as well as boughs from trees and shrubs in bloom. She established a cutting garden and built several greenhouses to produce a constant supply of fresh-cut flowers. An orchid grower joined Mrs. Post's garden staff to expand her collection of orchids to over two thousand plants, so that her home was always graced with these exotic blooms. Hillwood today continues Mrs. Post's tradition of placing blooming orchids and floral arrangements throughout the mansion.

French Parterre

To complement her collection of eighteenth-century French furnishings, tapestries, and decorative arts displayed in the mansion's French drawing room, Mrs. Post commissioned Innocenti and Webel to design and build a garden featuring typical formal elements of an eighteenth-century French garden.

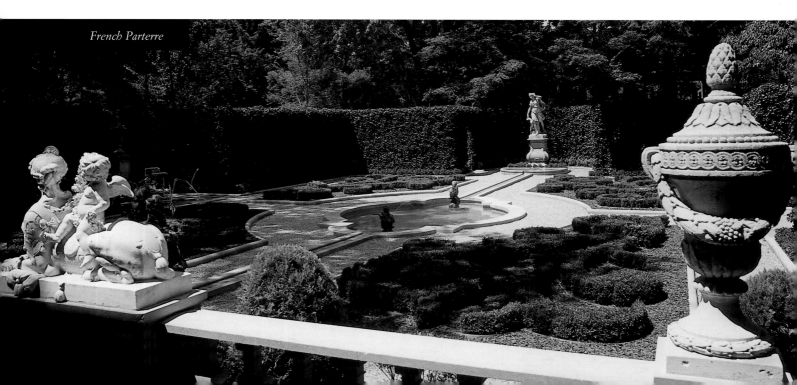

French Parterre

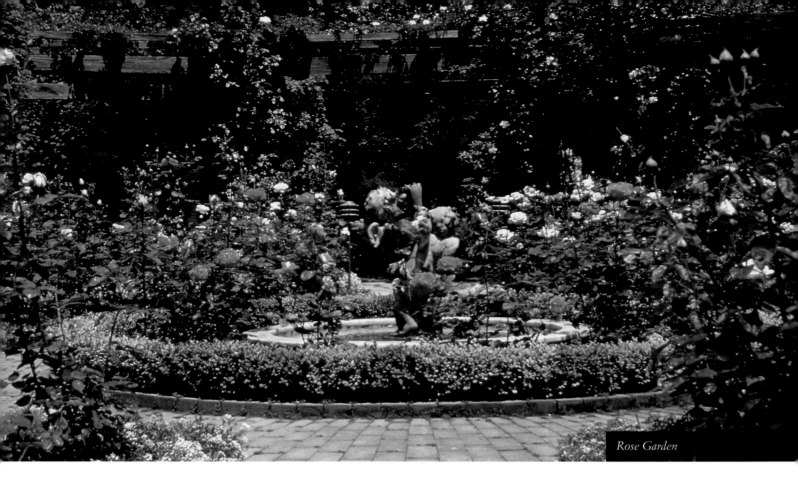

Rose Garden

The two landscape architects replaced an existing garden with a fishpond and perennial borders designed by the distinguished landscape architect, Rose Ishbel Greely. They laid out a small parterre in four quadrants separated by paths and centered on a shallow pool. Each quadrant contains a low hedge of English boxwood tightly clipped into a fluid, organic scroll pattern. The French doors from the drawing room open onto a terrace, the center of which features an elegant swan fountain of pink marble that drops water into a basin lined with Italian glass tiles.

At the opposite end of the garden, a small frog fountain spouts water into a second basin. Water from both basins spills over and into limestone rills, rippling into

the center pool where lead putti riding a dolphin and seahorse send streams of water splashing into the pool. The terrace balustrade, graced with white marble sphinxes and limestone urns, lends a formal contrast to the terra cotta sculpture of Diana, goddess of the hunt, located at the opposite end of the garden and framed by a curved hedge of hemlock.

These features lend the garden design a decidedly French flavor with Moorish influences typical of the eighteenth century. A high wall of English ivy encloses the garden ensuring privacy and intimacy—understandably so, given that the best view of the garden is from Mrs. Post's bedroom located above the French drawing room.

Rose Garden

Soon after acquiring Hillwood, Mrs. Post hired the young landscape architect, Perry Wheeler, to design a new rose garden. Wheeler had gained recognition for his work on the design and planting of the White House rose garden and for his innovative use of paving, creating intricate patterns in paths and walks.

The rose garden is built in a circular shape, joining a curved, wooden pergola built by the Erwins. Mrs. Post chose to keep the pergola, as it was beautifully draped with climbing roses and white wisteria. Opposite the pergola, workers planted American boxwood to complete the circle started by the pergola. Wheeler originally designed the garden with

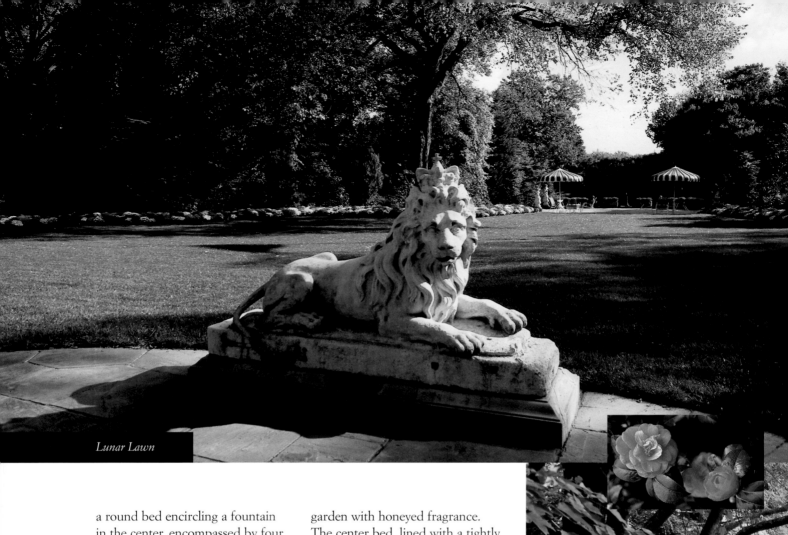

Lunar Lawn

a round bed encircling a fountain in the center, encompassed by four crown-shaped and eight crescent-shaped beds. Paths decorated with brick and stone inlays divide the beds. Mahogany benches, chairs, and tables, custom-built for Mrs. Post and set in the shade of the pergola, enable guests to relax and enjoy the fragrance of roses in bloom.

Each rose garden bed contains a different variety of floribunda rose and emperor tulip. The tulips bloom in April, followed by the flowering of roses in May. Long after the climbing roses have finished blooming in June, the floribundas continue to flower throughout the summer, while sweet alyssum grows along the edges of the beds, scenting the

garden with honeyed fragrance. The center bed, lined with a tightly clipped hedge of variegated English boxwood, teems with seasonal flowers to decorate Mrs. Post's memorial monument that replaced the original fountain.

Putting Green

Beyond the rose garden, and below a large stone staircase built by Willard Gebhart, the Erwins placed a parterre of boxwood and perennials. Mrs. Post removed this garden in 1955 and installed a nine-hole putting green in its place. Constructed of a fine bentgrass turf, the green is set with cups and pins and enclosed in a hedge of Japanese hollies to keep golf balls from rolling off the green. Here, Mrs. Post and her guests enjoyed

afternoons of leisurely exercise, resting under the large umbrellas placed at either end of the green.

Lunar Lawn

The front of the mansion, facing south toward a view of the Washington Monument, became Mrs. Post's favorite spot for entertaining. An Italianate *allée* (or garden lane) of American boxwood stretching from the portico to the terrace beyond was moved to the rose garden; a large crescent-shaped lawn took its place. Gardeners planted large, deep beds filled with spring-flowering trees, shrubs, and flowers under high-arching limbs of American elms to enclose the lawn and frame the view of the Washington Monument.

Along with the blooming trees and shrubs, thousands of tulips and pansies planted in wide borders around the beds add to the riot of color. When this breathtaking spectacle reached its peak in the first week of May, Mrs. Post hosted her annual garden party, considered to be one of the premiere social events of the Washington spring season. With the arrival of summer weather and the receding of the brilliant spring display, borders are planted with annuals, which make way for thousands of chrysanthemums in the fall.

Dacha

A version of the Russian single-room country retreat, the Dacha at Hillwood is the third one built by Mrs. Post. The first she erected at her summer camp in the Adirondacks, while the second graced the grounds of her former Tregaron estate in Washington D.C. It served as a library and study for her husband, Ambassador Joseph Davies. Mrs. Post built Hillwood's dacha in 1969 to house a collection of Russian art acquired by her dear friend Madame Augusto Rosso, whose husband served as Italian ambassador to the Soviet Union from 1936 to 1941. The building is constructed of California redwood and its windows and door frames

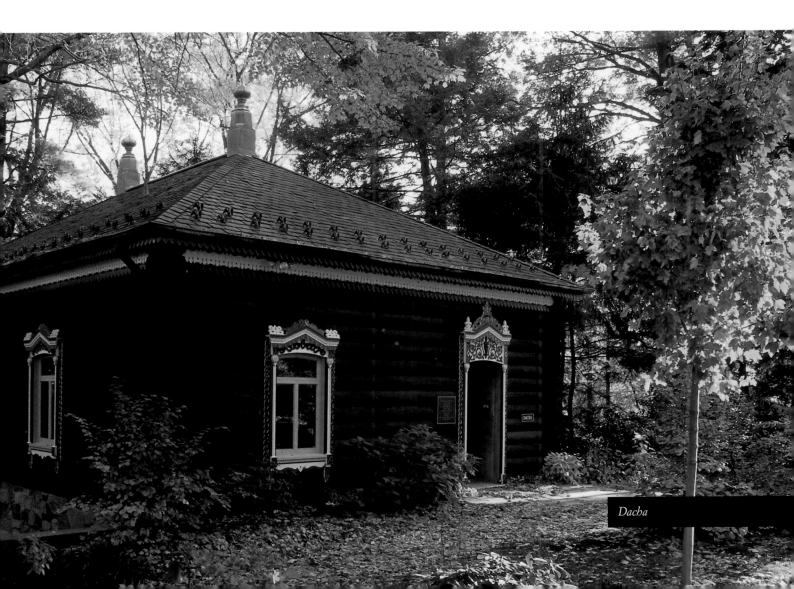

Dacha

Japanese-style Garden

are embellished with polychrome carving. Located within the woodland edge and surrounded by mature trees, the dacha functions as a focal point for the east walk around the lunar lawn.

Japanese-style Garden

The Japanese-style garden attests to a taste for oriental gardens influenced by the reintroduction of Japanese culture to America during the 1950s. Mrs. Post hired Japanese garden designer Shogo J. Myaida, who had become a naturalized citizen in the 1920s, when Japanese-style garden design enjoyed great popularity among the American elite.

Myaida developed a style of garden construction that blended the traditions of Japanese architecture and garden design with the practicality of American tastes. He chose not to follow the strict tenets of Japanese practice, but created a Japanese-influenced pleasure garden that fulfilled the desires of its owner. His design evokes a traditional mountain setting in miniature, with a mountain stream cascading from an evergreen forest into a series of ponds and waterfalls, finally coming to rest in a placid lake below. More than four hundred carefully placed boulders create an illusion of a rocky mountainside. Myaida introduced traditional gates, bridges, stuppas, and lanterns in the garden. He blended trees and shrubs typical of Japanese gardens—cryptomeria, cherries, azaleas, Japanese maples, pines, iris, and lotus—with indigenous plants that grew in the garden's bordering woodland. Long after Myaida completed the

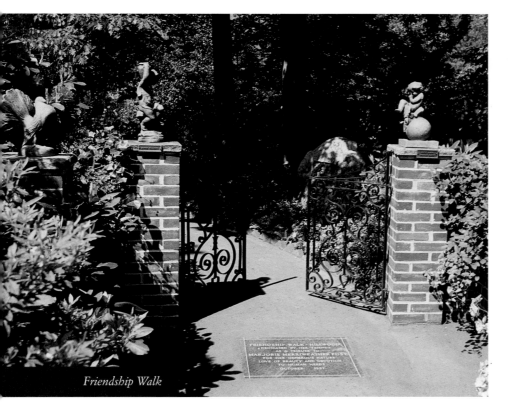

Friendship Walk

Pet Cemetery

In a wooded site affording a private spot to reflect and repose, Mrs. Post built a memorial garden to her pets. The garden features markers with the names of each pet, as well as statues of dogs offering a flower-filled basket. Each marker is set in plant beds that echo the mood of the garden, such as weeping dogwood, lily-of-the-valley, bleeding heart, dog-tooth violet, and forget-me-nots.

garden, Mrs. Post continued to embellish it with statuary and plants.

Friendship Walk

In 1957, two years after she purchased Hillwood, four of Mrs. Post's closest friends had the idea of honoring her civic philanthropy by commissioning a friendship walk as a birthday present. They worked closely with landscape architect Perry Wheeler and Mrs. Post's head gardener to design a garden worthy of her generosity to others. In October of that year, Mrs. Post's friends gathered with her in the garden to dedicate the garden to her friendship and present their gifts of sculpture and statuary.

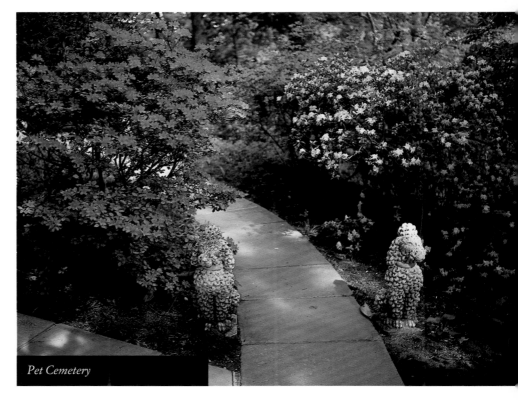

Pet Cemetery

Adirondack Building

Mrs. Post spent her summers at her Adirondack Mountain retreat, Camp Topridge. She decorated its great house with Native American objects, which she bequeathed to the Smithsonian Institution before her death. Through a long-term loan agreement with the Smithsonian, significant pieces from the original collection are now exhibited at Hillwood in a rustic building built in 1982 and inspired by the design of the great camps built in the Adirondacks during the early part of the twentieth century.

Cutting Garden

Mrs. Post laid out the cutting garden in one of the estate's service areas to provide a succession of seasonal blooms for her house. In keeping with her wish to beautify the mansion with fresh flowers in perpetuity, the garden continues to yield a bounty of blooms from bulbs, annuals, and perennial cut flowers. Arrangements follow the styles popular during the 1950s and 1960s.

Greenhouses

Upon acquiring Hillwood, Mrs. Post added four greenhouses around the one that stood on the property in order to cultivate her large orchid and tropical plant collection. She hired an orchid grower to expand her collection to more than two thousand orchids, which, when in bloom, embellish the mansion's interior. Mrs. Post so loved her orchids that she often had the grower ship large selections to her other homes while she was in residence there.

Mrs. Post later added a sixth greenhouse for the production of cut flowers in winter when the cutting garden ceased to yield. In autumn, standard chrysanthemums fill the greenhouse, followed by freesias, lilies, snapdragons, stock and bells of Ireland. The greenhouses also furnished the mansion with potted poinsettias, amaryllis, azaleas, hydrangea, and camellias.

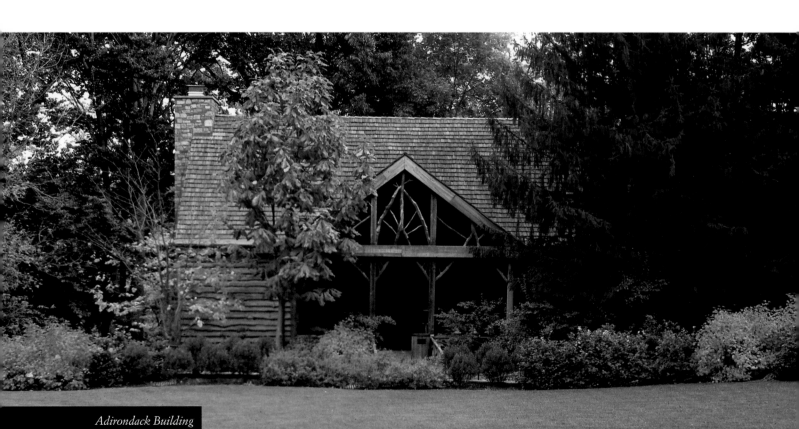

Adirondack Building

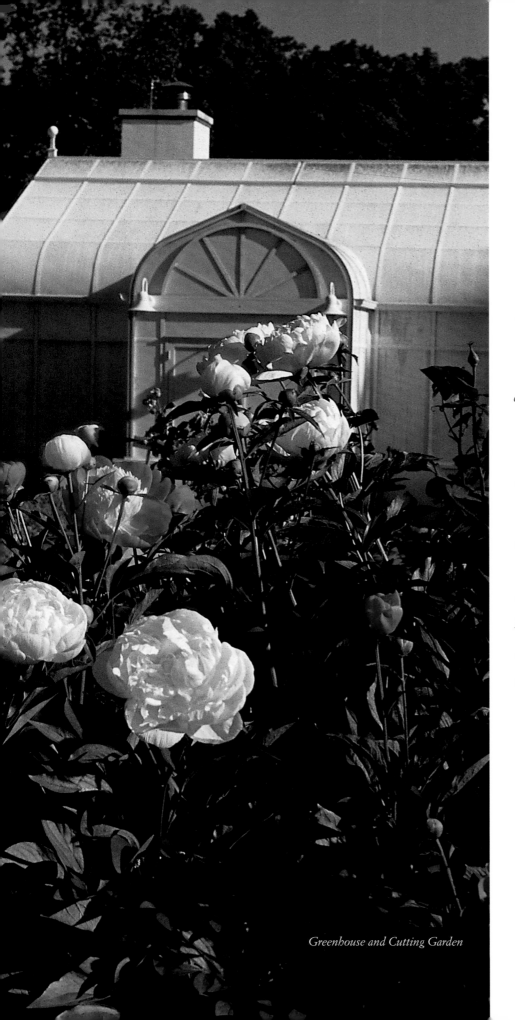

Greenhouse and Cutting Garden

A tour of Hillwood's gardens perfectly complements a visit to the mansion with its displays of Mrs. Post's French and Russian collections. The love of color and variety, intricate pattern, and association with foreign lands can be seen both in rooms of art objects and in the design and planting of Hillwood's grounds. The museum and gardens are two sides of the same coin: Mrs. Post's distinctive taste and desire that future generations have the opportunity to share her love for the beauty of both art and nature.

Highlights of the Collection

Most of Marjorie Merriweather Post's collection of fine and decorative arts is displayed at Hillwood just as she had originally assembled them throughout the rooms to embellish her magnificent home. As such, their impact, while appropriate to their original context, can sometimes be diminished because of their decorative function. This section puts into chronological order, highlights of some of the collection's most noteworthy works of French and Russian art.

Detail of Roll-top Desk
(see page 16)

The French Collection

Detail of *L'Enfant Chéri*
(see page 64)

Luxury Arts of Louis XIV

The reign of Louis XIV (1661–1715) brought about an era of unprecedented richness to the decorative arts. Droves of foreign craftsmen arrived in France with the hope of court commissions. But during this time, France also experienced the loss of a group of highly skilled artisans, the Huguenots or French Protestants who emigrated en masse during the 1680s.

The court of Louis XIV had the aristocracy participate in a grand scheme to protect French industries by tightly controlling life, fashion, and social etiquette.

France had formerly relied on other countries for the production of luxury goods, but during the second half of the seventeenth century, the court undertook a conscientious effort to reduce imports. Jean-Baptiste Colbert, controller general of finances under Louis XIV, sponsored a series of enterprises to produce luxury goods. The royal workshops at the Gobelins went beyond merely furnishing the royal residences to instituting new technical standards and creating a distinctive French style, one that delicately balanced baroque exuberance and classical restraint. All these factors had a critical impact in the development of styles in the eighteenth century.

Above left

*Watch with
Miniature of Catherine I*
London, ca. 1720

The watch's bold baroque engraving is the work of a Huguenot silversmith. Its Louis XIV-period style of ornament exemplifies how the French "grand style" traveled across Europe and to Britain through emigrant craftsmen.

Left

Embroidered Panel
France or Italy, early 18th century

The decorative motifs of this vibrant
silk and cotton embroidery are
naturalistic and may allude to Spring.
The interspersed acanthus scrolls,
popular during the late baroque
period, derive from classical sources.
The clear organization of decorative
elements suggests a French origin.

Opposite

Box with Vulcan
France, first quarter
of the 18th century

The cover depicts Vulcan making a
suit of armor, while Minerva seated on
a cloud looks on. Although the work's
attribution is difficult, the solemn
classical style of decoration reflects the
taste of the late baroque.

Rococo during the Regency and under Louis XV

Above

Shell-Shaped Snuff Box
Paris, 1723

One of the earliest examples of a jeweled snuffbox, the work bears ornamentation that is indebted to the baroque formality of the reign of King Louis XVI, while the shell form announces the advent of rococo.

After the death Louis XIV in 1715, the French nobility's desire to escape the suffocating etiquette and imposed expenditure demanded by the Sun King led them to flee Versailles for Paris. The advent of the duc d'Orléans as Regent of France during the minority of Louis XV ushered in a period of unprecedented prosperity and a consequent building frenzy that created a great demand for luxury goods. In Paris, the old aristocracy encountered a new group of wealthy individuals, financiers, and upper bourgeoisie who had profited from the nation's robust economy and extended peace.

These fashionable Parisians spurred the formation of a new style, the rococo, which expressed first and foremost the elite's *joie de vivre* and sense of freedom. Asymmetrical, organic compositions superseded the solemn classicism of the late baroque period of Louis XIV. Decorative schemes of novel lightness prevailed. An increasing demand for privacy dictated smaller rooms, conceived in more human scale. Furniture makers outdid themselves in creating new shapes with a variety of purposes to furnish the new dwellings of the rich.

No longer was the court the sole arbiter of taste. The rococo

*Candelabra with Vincennes Flowers
and Meissen Figures*
Paris, ca. 1750

Elaborate confections in mixed media
and ormolu-mounted porcelain like
these candelabra were a specialty of
the fashionable Parisian *marchands-
merciers*, dealers in decorative arts.
The pink shade softens the glare of the
candlelight.

Console Table
Paris, ca. 1730

Tables such as this were designed to
match specific architectural interiors
and often were placed under a mirror,
between windows, or opposite a
mantelpiece. Its elaborately carved
decoration with organic and fantastic
qualities enjoyed great popularity
during the rococo period.

style expressed the aspirations and
aesthetic preferences of the urban
elite as much as it did the taste of
the new king and his circle. Being
such an extreme artistic expres-
sion, from the outset rococo had its
detractors. As it became ever more
extravagant during the 1740s,
criticism mounted. Ultimately, by
mid-century the movement had
declined with the arrival of a
cooler, more rational movement—
neoclassicism.

Neoclassicism
under Louis XVI

Above

Box with Catherine as Minerva
Paris, 1781–82

The association of Catherine II with the goddess Minerva alludes to the enlightened ruler's virtues and strengths. The box, sold at the shop *Au Petit Dunkerke*, may commemorate the visit of Catherine's son Paul and his wife Maria Fedorovna to Paris in 1782.

Neoclassicism resulted from a concerted program of intellectuals, architects, and designers to restore principles of classical antiquity to art and design. The discovery of the ruins at Herculaneum and Pompeii, as well as the official tours of artists and architects to Rome, revived classical ornamental vocabulary and induced a new sense of dignity, balance, and harmony to artistic productions. Theoreticians pleaded with artists working in the rococo style to "stop twisting what should be straight."

Neoclassicism not only helped legitimize and strengthen the power of France's new rulers, it also became a vehicle of expression for Enlightenment ideas. Stylistically, it revived linearity and stressed the importance of the classical orders and Antiquity as design sources. Academic painting and sculpture self-consciously incorporated theories put forth by intellectuals concerning the superior morality and virtue of Greek and Roman models.

A milder interpretation of the antique became fashionable for interiors and furnishings. In the decorative arts, chairs and commodes abandoned the curvaceous contours of the previous era. The style branched into two streams: a severe interpretation favored by intellectuals and a lighter, more feminine

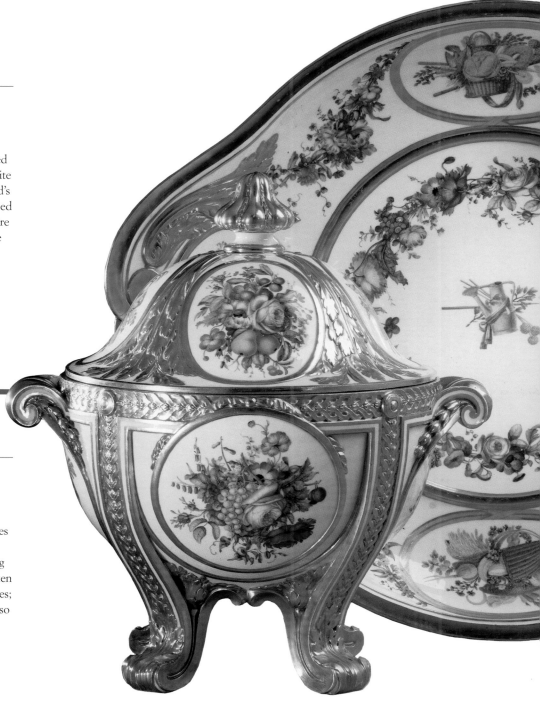

Opposite

L'Enfant Chéri
Marguerite Gérard
Paris, ca. 1790

One of the few and most recognized female painters of her day, Marguerite Gérard was Jean-Honoré Fragonard's sister-in-law and pupil. She specialized in intimate domestic scenes that were both elegant and sentimental. The painting demonstrates her skill at reproducing various textures and creating subtle tonal effects.

Right

Soup Tureen and Platter
Sèvres, ca. 1783

The soup tureen displays floral decoration and horticultural trophies that attest to the love of pastoral themes in aristocratic circles during the neoclassical period. The king often gave such pieces to foreign dignitaries; presumably this and its pair were also part of an official gift.

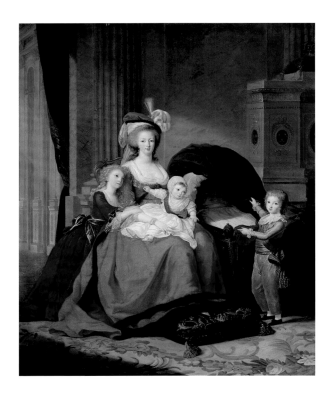

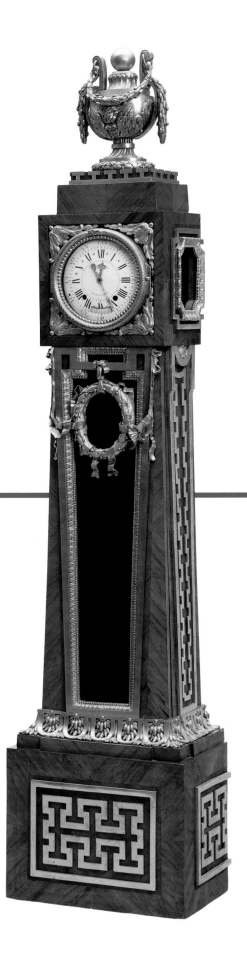

version championed by Marie Antoinette and the court. Many decorative pieces depict pastoral scenes in keeping with the favored pastime of the elite—imitating shepherds and milkmaids. Swags and flowers fill many of the works of the period. Similar clusters, suspended from ribbons, adorned architectural elements and furnishings alike. Elegant arabesques appeared everywhere. The period's best productions shared an aesthetic of jewel-like refinement in most decorations.

Above

Marie Antoinette and Her Children
After Elizabeth Vigée Lebrun
ca. 1790

A copy of the portrait of the Queen with her children at Versailles, the canvas portrays her as a mother in a domestic situation in order to convey her soft, maternal side at a time when her popularity was at its lowest level.

Right

Standing Clock
Balthazar Lieutaud, cabinetmaker,
Ferdinand Berthoud, clockmaker
Paris, ca. 1760

The clock's rectilinear shape and bold, stiff bronzes represent a radical departure from rococo taste and offers a severe, uncompromising manifestation of neoclassicism.

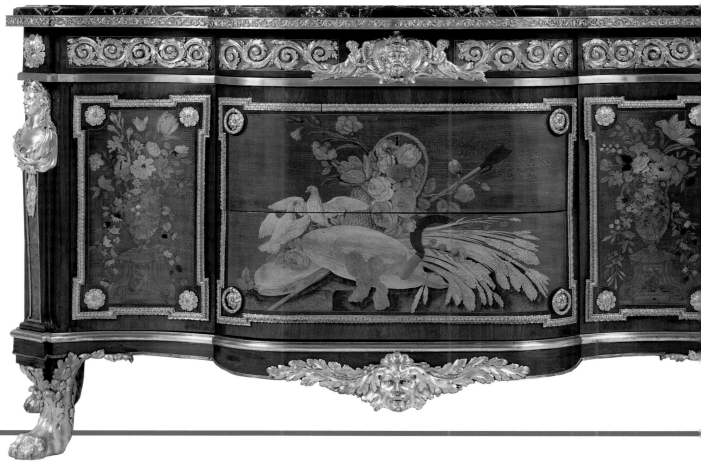

Above

Commode
Jean-Henri Riesener
Paris, ca. 1775

The monumental commode by the king's cabinetmaker features highly sculptural bronzes, superbly executed naturalistic marquetry, and an elaborate tripartite shape and ingenious locking mechanisms, all characteristic of Riesener's work.

Right

Negress Clock Case
Paris, ca. 1785

A similar, ingenious clock was delivered to Queen Marie Antoinette at Versailles in 1784. Before that, it appeared in the shop-window display of its maker J. B. Furet. By pulling on the figure's earrings, movements in the head activated the hours shown in the eyes; the pedestal would have housed a music box.

Revolution and the Empire Style

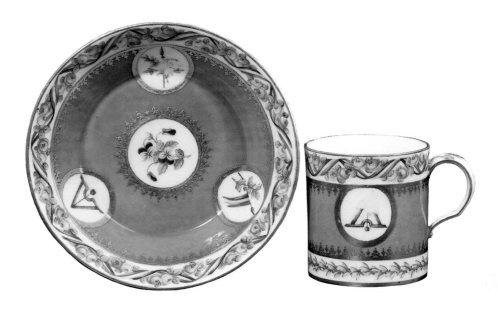

The outbreak of the French Revolution in 1789 halted the production of luxury art, while the abolition of aristocratic privileges eliminated the main group of consumers of these objects. At the same time, the disappearance of the guild system regulating the activities of artists and artisans threw decorative arts production into disarray. Nevertheless, the French Royal porcelain factory at Sèvres survived the death of the king by producing wares that either catered to a foreign market or incorporated revolutionary symbols.

During the Consulate and First Empire, Napoleon's architects and

Above

*Cup and Saucer with
Revolutionary Symbols*
Sèvres, 1794

At the time of the revolution, Sèvres produced a number of pieces imbued with the current republican spirit and intended for the domestic market. The set bears allegorical references to Liberty, Equality, and Reason, as well as Masonic symbols extolling republican virtues.

Opposite above

*Louis XVI Saying Farewell
to His Family*
Mather Brown, 1793

Brown depicted the moment when the revolutionary soldiers arrived at the Temple to take King Louis XVI to the guillotine. Family members and loyal servants weep and embrace the king.
An American, Brown practiced in England where he trained in Benjamin West's studio under the tutelage of Gilbert Stuart.

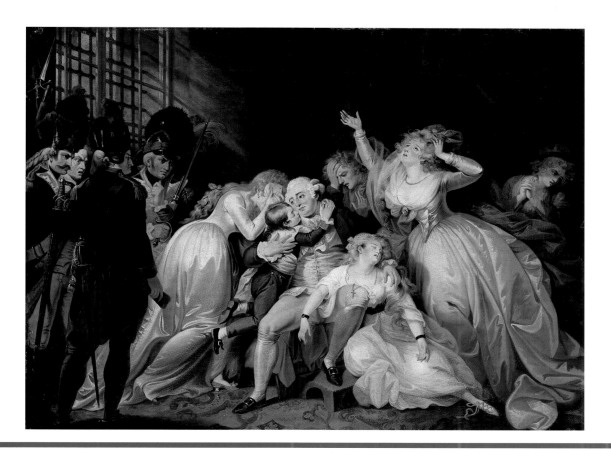

*Plate with Etruscan Border and
Bird, after Buffon*
Sèvres, 1794

During the revolutionary era, the
Sèvres factory concentrated on foreign
markets because it could not depend
on royal commissions and purchases
by French aristocrats. The austere
decoration of the service reflects the
current republican spirit. Exported to
England, the plate derived its image of
a bird from Buffon's *Histoire Naturelle
des Oiseaux.*

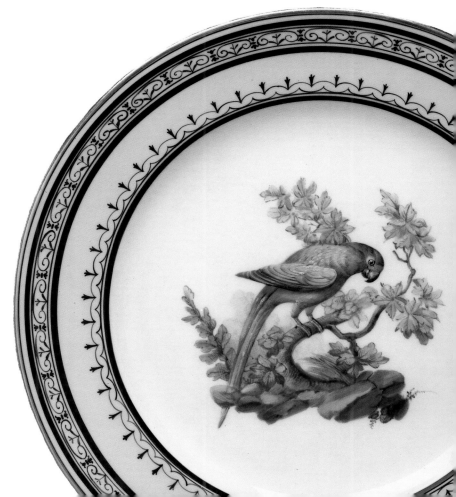

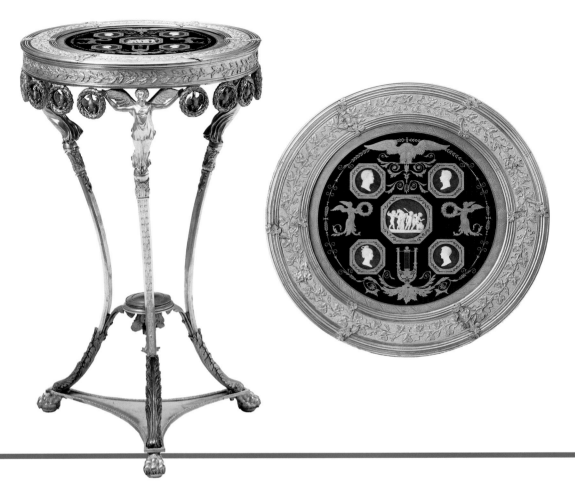

designers formulated the so-called Empire style, yet another interpretation of classicism with a certain mixture of exoticism. Napoleon's favorite practitioners, Percier and Fontaine, recommended that all decoration draw from the same logic, bringing an unprecedented cohesiveness to the new style. The Empire style spread throughout Europe as Napoleon's army waged war across the continent.

During the Consulate, Napoleon's campaigns in the Middle East gave rise to the popularity of Egyptian decorative elements. Once crowned Emperor, Napoleon favored the model of Imperial Rome to express the majesty and grandeur of the regime's dominating, dictatorial position. So uniform and widespread became this style that it is often difficult to tell whether an object from the period comes from Paris, Berlin, Vienna, or St. Petersburg. During this period, the decorative arts received a great boost from the regime's commissions to artisans as a measure to stimulate the economy, an idea that hearkened back to Colbert's policies during the reign of the Sun King Louis XIV.

Porcelain and Gilt Bronze Table
Königliche Porzellan Manufaktur
Berlin, 1817–23

Made as part of the dowry of Princess Charlotte of Prussia when she married Grand Duke Nicholas in 1817, the table features their profiles at the bottom, while Emperor Alexander I (Nicholas' brother) and King Friedrich Wilhelm III of Prussia (Charlotte's father) appear on the top (see above right). The gem representing the marriage of Cupid and Psyche alludes to the betrothal of these two ruling families.

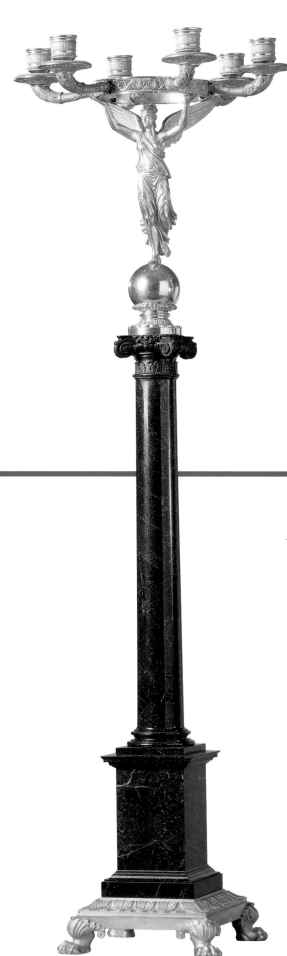

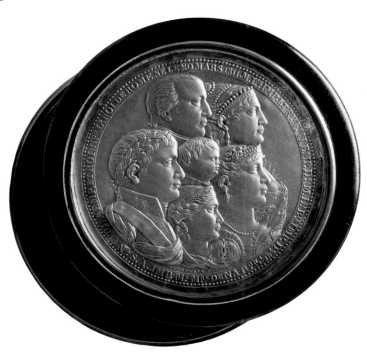

Left

Lapis Candelabra
St. Petersburg or Paris
First third of the 19th century

As Napoleon's policies spread across
Europe, so did the Empire style. The
candelabra's victory figures derive
from French models; but their
manufacture might very well be
Russian, or a combination of both,
namely the lapis columns Russian and
the bronzes French.

Above

_Box with Medal of Napoleon,
Marie Louise, and Their Family_
Paris, 1811

Napoleon astutely recognized the
important link between artistic
production and France's economic
health. He therefore embarked on an
ambitious program of refurbishing
imperial residences and created a style
that would help legitimize his rule.
This medal is an official portrait of the
imperial family.

Revivalist Styles of the Nineteenth Century

In France, the Congress of Vienna (1814) resulted in the restoration of the Bourbon monarchy. This had the effect of prolonging the Empire style with slight modifications for the first quarter of the new century. Characterizing all styles from the Revolution through the Second Empire was a reuse and combination of old forms that made this a quintessentially eclectic period. Much of the decorative arts of this period turned its back on the clarity of the previous neo-classical style, which became increasingly viewed as bleak and severe. The European middle class joined the ranks of luxury-goods consumers, reveling in the richness

Above

Compote from the South American Bird Service
Sèvres, 1819

Conceived by Alexandre Brongniart, director of the Sèvres factory in collaboration with Mme. Knip, a noted bird painter, the compote depicts birds painted from life and of a species represented in the Jardin du Roi. The floral border reflects each bird's South American habitat.

Right

Portrait of Empress Eugénie
Franz Xavier Winterhalter, 1857

Empress Eugénie, wife of Napoleon III, fostered the revival of historicist styles, especially that of Louis XVI. The much-sought-after court portraitist Winterhalter recorded the Empress's beauty in a series of works that contributed to the Second Empire's image of glamour and charm.

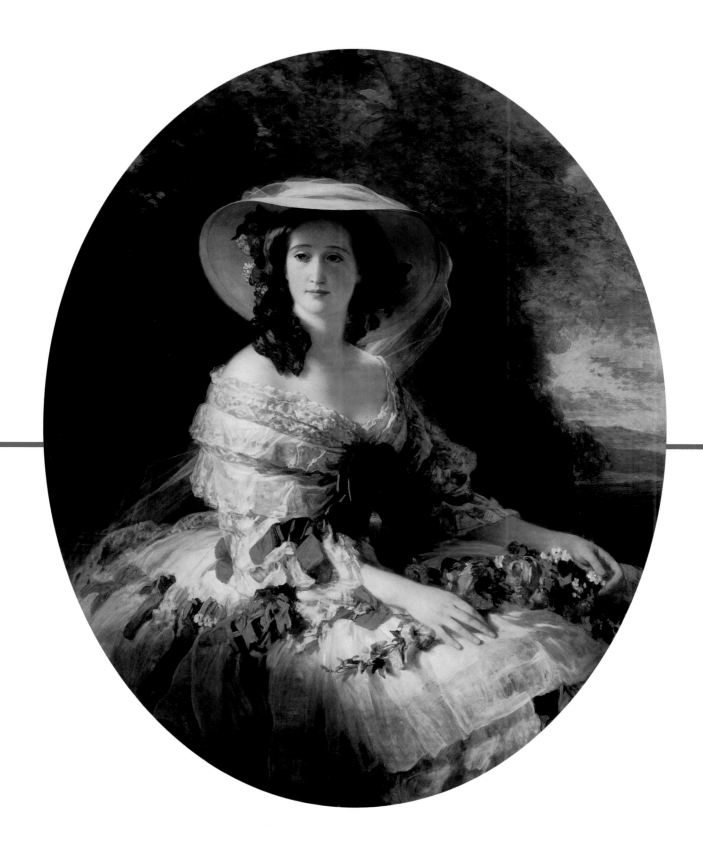

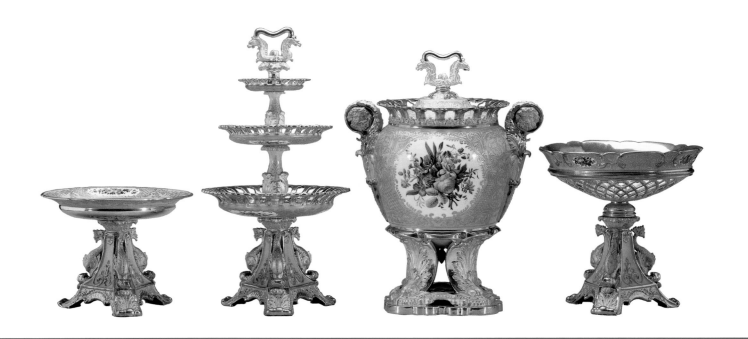

of ornament, its colorfulness, and the amalgam of disparate motifs from all conceivable sources.

From the 1830s onward, large-scale expositions spurred the development of the industrial arts and made them available to a wider audience. These exhibitions offered viewers a dazzling array of nineteenth-century artistic revivals, from classical antiquity and the medieval Gothic style to a renewed interest in the Renaissance, baroque, and rococo periods. This eclectic mix would characterize much of European artistic production until the end of the century. Each country understandably gravitated toward styles that

reflected its national identity. For example, French fashion during the Second Empire emulated the style of Louis XVI, which Empress Eugénie fervently admired. At the same time, Renaissance models exerted an undeniable artistic influence all across Europe.

Above

Pieces from a Dessert Service
Jacob Petit Factory, 1835

The service exemplifies Jacob Petit's flamboyant interpretation of the rococo revival of the 1830s. The work's highly sculptural qualities, profusion of flowers, bright colors, and lavish gilding represent Petit's unique and creative interpretation of his 18th-century models.

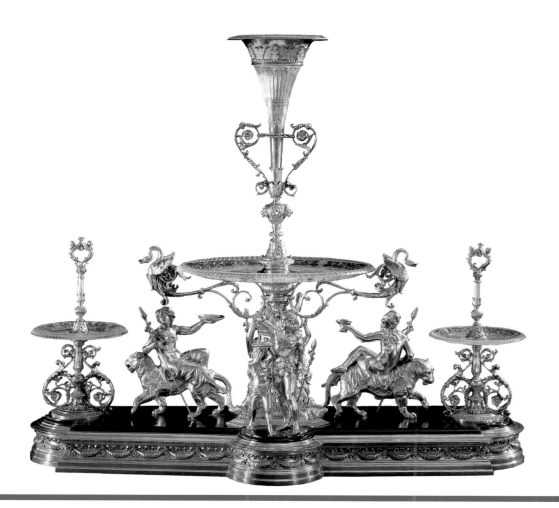

Centerpiece from a Table Garniture
Firm of Vinzenz Mayer's Sons
Valentin Tierich, designer
Vienna, 1873

Created as an exhibition piece for the
Vienna International Exhibition of
1873, the centerpiece—part of a
seven-piece table garniture—depicts
Dionysian imagery related to the
pleasures of eating and drinking. Made
by an imperial firm of court jewelers,
the work reflects its designer's status as
a professor of ornament who greatly
advanced Vienna's decorative arts
reform movement.

The Russian Collection

Detail of *A Boyar Wedding Feast*
(see page 97)

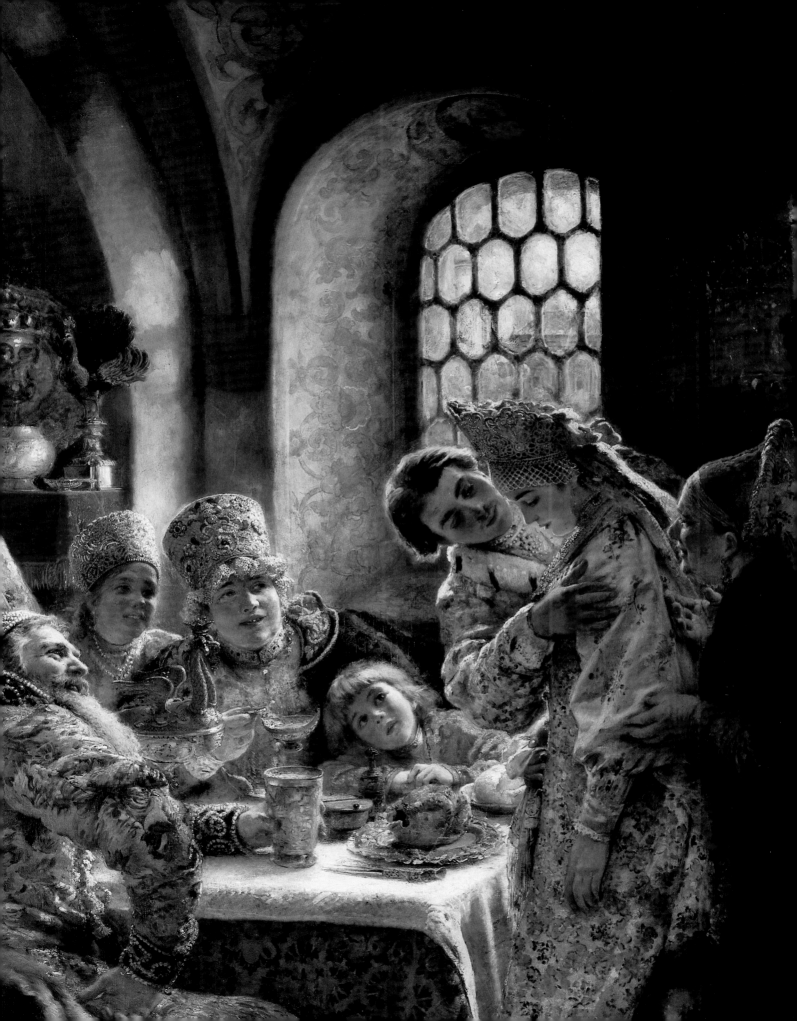

Russia before Peter
1500–1690

Above

Bratina
Russia, early 17th century

A bratina is a traditional Russian drinking vessel that was filled with *kvas* (a rye-based drink), wine, or beer and passed around the table at the end of a meal to drink to the health of the host. As the inscription exhorts the guest, this is the "Bratina of an Honest Man, Drink from it to your Health."

Above right

Icon of St. George
Russia, 16th century

The subject matter and composition of this large icon depicting St. George slaying the dragon may have come from the northern city of Novgorod. The victorious warrior saint astride a white charger was particularly popular in that city, as was the commissioning of an icon in which the central figure is surrounded by bust-size figures of Christ, the Mother of God, saints, and archangels. In doing so, the client was able to specify an array of saints who were of special significance to himself and his family.

During the fifteenth, sixteenth, and early seventeenth centuries, Russia remained largely closed to outside influences in painting, dress, music, manners, and literature. Nevertheless, wealthy Russians—usually those living in major trade centers—did enjoy luxury goods from both east and west. The Russian tsars, for example, employed Italian architects, German enamellers, Ottoman metalsmiths, and Austrian heraldry masters to build cathedrals and supply imperial regalia. The intermingling of Russian, western, and eastern tastes is apparent in an early seventeenth-century *kovsh,* a vessel that could be used as a ladle, drinking vessel, or serving bowl. While the *kovsh* takes a native

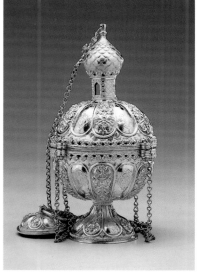

Russian form, the floral ornament of its interior and handle reveals Persian influence born of seventeenth-century trade and diplomatic relations.

Religion dominates much of Russia's culture during this early period. While painters in other countries depicted scenes of daily life or royal exploits, Russia's artists concentrated on producing frescoes and icons for church use and private veneration at home. Although metalworkers could produce delicately decorated secular vessels such as the *bratina*—a sort of "loving cup" typically passed around a table at the end of a meal—wealthy Russians spent enormous sums on lavish chalices or censers to be donated to churches and monasteries.

Above left

Kovsh
Russia, early 17th century

Originally made of wood, a kovsh such as this could serve as a ladle, drinking vessel, or a serving bowl. This particular piece exhibits the silversmith's talent in hammering out a single, gracefully curving piece of metal that is crowned with a cast form of a pinecone. The floral ornament visible on the handle is reminiscent of Persian decoration at the beginning of the 17th century and reveals the influence of trade and the exchange of diplomatic gifts.

Above

Censer
Russia, late 17th century

This silver and parcel-gilt censer held incense used during Orthodox divine services. While early censers often took the form of churches, this one retains only a distinctive onion dome at the top. An ornate inscription written on alternating panels around the body tells that in 1681 a certain Abbott Joseph donated this beautiful object to a monastery "in remembrance of his soul and of his parents."

The Westernization of Russian Elite Culture

Peter the Great to Anna Ioannovna

1690–1740

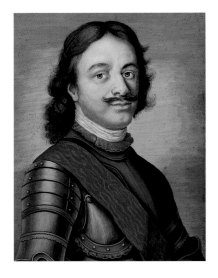

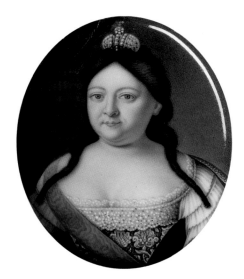

Historians generally credit Peter the Great with forcibly imposing western European culture on his often reluctant subjects. Although his predecessors had hired a small group of architects, artists, and artisans from abroad, Peter greatly increased the number of foreign craftsmen plying their trade in the new Russian market. Indeed, the tsar used his iron will to alter

Above left

Portrait of Peter the Great
artist unknown, late 18th century

Above right

Miniature of Anna Ioannovna
artist unknown, 1730–40

fundamentally the daily life, dress, and manners of the Russian nobility. Naturally, these changes affect the decorative arts. New customs of dining, drinking, celebrating, socializing, and furnishing one's home demanded that the Russian elite rely on markets abroad or patronize artisans who were themselves foreign or could produce goods in the foreign manner.

Early in Peter's reign, fashion gravitated toward the massively proportioned and balanced baroque style of the Netherlands, Scandinavia, and Central Europe. After a 1717 trip to France, the splendors of the royal court expanded the monarch's taste to

include lighter, more lively French designs. Both successors—his wife, Catherine I, and his niece, Anna Ioannovna—spurred the Russian market for luxury goods and attracted foreign craftsmen such as glass engravers from Eastern Europe or French silversmiths who sought their fortune in Russia while passing on their skills to local artisans.

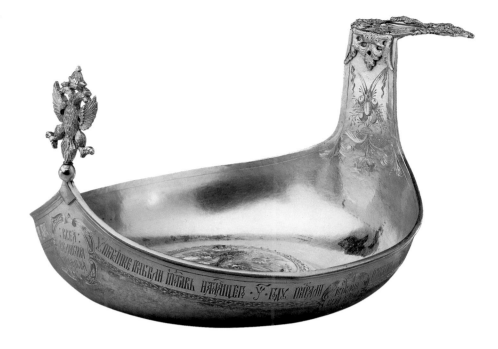

Kovsh
Moscow, 1702

In the 18th century, kovshi were given as gifts, often to tax collectors and leaders of military units for their loyal support of the empire. An inscription on this particular kovsh states that Peter the Great granted it to Mikhail Syreishikov, a liquor tax collector in Novgorod, for his exemplary work. In the mid-17th century the tsar controlled a monopoly on all taverns. These taxes provided a substantial income for the crown, and tax collectors such as Syreishikov played a significant role in the Russian economy.

Opposite

Coffee Pot
Nicolaus Dohm
St. Petersburg, 1735

This coffee pot is part of a service created for Empress Anna Ioannovna by Nicolaus Dohm, a Frenchman and one of the first recorded silversmiths in St. Petersburg. Foreign craftsmen played an essential role in bringing new styles to Russia and this pear-shaped coffee pot shares both its form and its design with European silver of the first half of the 18th century.

Left

Goblet with a Portrait of Anna Ioannovna
Iamburg Glassworks
1730–35

This goblet decorated with a bust-length portrait of Empress Anna Ioannovna was made at Iamburg, one of Russia's first glassworks. Because the technology of making, cutting, and engraving colorless glassware was relatively new, numerous artisans were brought in from Central and Eastern Europe to train Russian craftsmen. The high quality, complexity, and accuracy of the engraving on this goblet suggest that it is the work of the Bohemian engravers Christian Fershtel, or his son Johann, both of whom worked at Iamburg early in Anna Ioannovna's reign.

Continuing Peter's Revolution

Elizabeth I

1741–1761

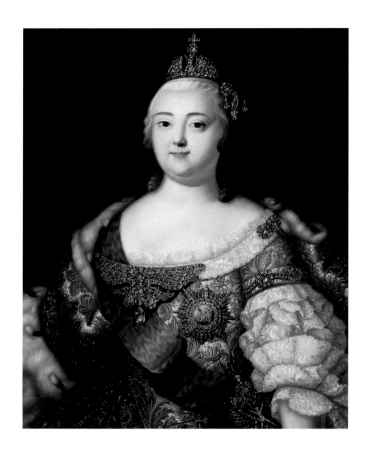

Above

Kholmogory Jewel Box
Kholmogory, mid-18th century

This box in the shape of a drop-front desk was used to store jewelry and cosmetics. It was made of walrus ivory in Kholmogory in far northern Russia. In the 18th and 19th centuries, it thrived as a center of walrus ivory carving, becoming famous for its ivory combs, snuffboxes, and other decorative objects.

Above right

Portrait of Elizabeth I
artist unknown, 1740s

One figure dominates Russian culture during the mid-eighteenth century—Empress Elizabeth I, the daughter of Peter the Great. Throughout her twenty-year reign, she upheld and extended his intellectual and cultural programs, establishing Russia's first university in Moscow and an Academy of Arts like those in Paris and London. She also continued her father's active campaign of building grand palaces and gardens.

The lavishness of her court attracted foreign artisans to Russia, while the demand for luxury goods stimulated the rise of domestic entrepreneurs to satisfy this lucrative market. Elizabeth, herself, exhibited some of this spirit when in 1744 she established the Imperial Porcelain Factory, one of Europe's earliest manufactories.

During her reign a preference for French language and etiquette took firm hold among the nobility. In the visual arts, this fondness for things French led to emulation of the French rococo, an exuberant, often ornate style based on organic and asymmetrical motifs, such as the shell, or *rocaille*, which gave the movement its name. A love for the exotic or the unexpected shows up in the Imperial Porcelain Factory's plate decorated with a *chinoiserie*, or a Chinese scene, and in the snuffbox made from the shell of a turban snail.

Left

Footed Beaker with Cover
St. Petersburg Glassworks
St. Petersburg, 1741–61

The distinctive shape of this piece indicates the clear influence of Central European decorative arts. In Silesia, located in modern-day Poland, glassworkers placed the bowls of goblets directly on a foot without placing a stem between. As this piece demonstrates, this form offered the engraver the opportunity to cover the entire surface with profuse ornament that could then be picked out in colored enamels.

But, Russian patrons were not slavish followers of French fashion, nor did they favor the most flamboyant designs. Artists tempered rococo's most exuberant qualities with more restrained forms to satisfy their Russian clients; examples include the footed glass beaker, copied from Silesian designs, or the balanced composition of an ivory jewel box in the shape of a drop-front desk.

Below

Snuffbox
Velikii Ustiug, 1750s–60s

The silver lid of this snuffbox, engraved with a copy of a French print depicting a shipwreck, has been designed to fit the shape of the polished green turban snail shell that forms its bottom. The shell originated in China, where it was most likely used as a ceremonial wine cup. The combination of such unusual and unexpected materials clearly illustrates an interest in the exotic, a key trait of the rococo.

Above

Dessert Plate with Chinoiserie
Imperial Porcelain Factory
St. Petersburg, 1760–62

Chinoiserie, or imaginary scenes of life in China, had been an important decorative device for over a century by the time this plate was made. The central scene depicting two small children at play was copied from a print by Jean-Baptiste Pillement whose designs in the Chinese taste were so popular that they were copied onto textiles, tiles, ceramics, and wallpapers.

Neoclassicism

Catherine the Great and Paul I

1762–1801

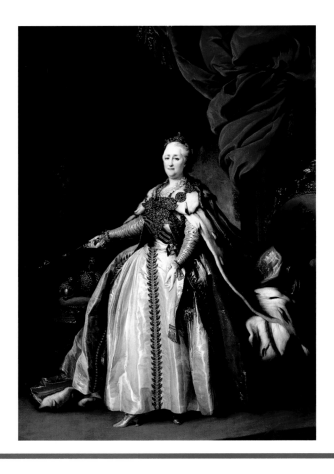

Childless herself, Empress Elizabeth I designated her nephew Peter to be her successor. History barely recalls Peter III and his short reign of six months, because his wife and successor, Catherine the Great, so thoroughly overshadowed him. During her reign, and that of her son, Paul I, Russia entered an unprecedented era of cultural flowering, much of it due to Catherine's visionary leadership. She became one of the eighteenth century's great art patrons and laid the groundwork for the State Hermitage's magnificent collections with significant purchases of western European paintings and sculpture. She also commissioned major works from French and British ceramic manufactories and hired foreign architects to create marvelous new palaces.

Catherine's personal ambition equaled that of Peter the Great. In her reformist zeal, she sought to implement some of the liberal political ideals of the French Enlightenment. She counted several *philosophes*, or French thinkers, among her circle of close friends and correspondents. Her intellectual interests led logically to a taste for neoclassicism, a style that elevated the architecture and design of ancient Greece and Rome. Artists abandoned the exuberance and complicated lines of rococo in favor of more austere, even severe designs. Her son, Paul I, and his wife, Maria Fedorovna, also figure as great patrons, making their court a center of fashion both before and during their brief rule.

Above

Portrait of Catherine II
attributed to Dmitrii Grigor'evich
Levitskii, ca. 1788

Opposite

Portrait of Paul I
artist unknown, 1796–1801

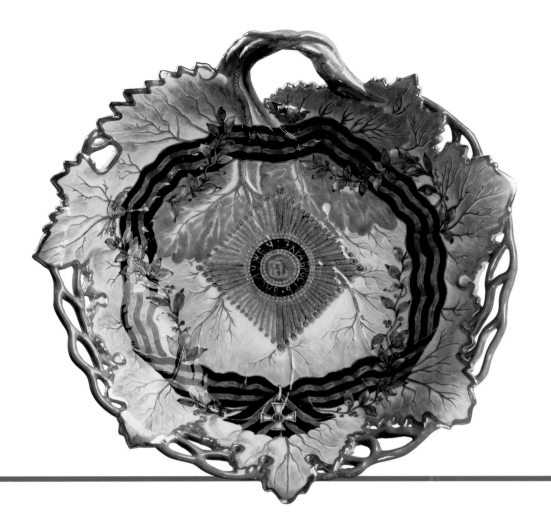

*Leaf-Shaped Dish from the Dessert
Service for the Order of St. George*
Francis Gardner Factory
1777–1800

As part of his program of
Westernization, Peter the Great
founded three knightly orders in
imitation of the medieval practice.
Catherine II, following him, founded
an additional two. In 1777, she
commissioned dessert services to be
used for each order's annual
ceremonial banquet from the Francis
Gardner Factory outside Moscow. As
a sample of what she wanted,
Catherine provided leaf-shaped dishes
from the Berlin Service Frederick the
Great gave her in 1772. Each piece
was then embellished with the order's
star and ribbon.

Two-Handled Cup with Lid and Saucer
Imperial Porcelain Factory
St. Petersburg, 1790s

Like the green wine glass, the simplified silhouette of this lidded cup and saucer demonstrates the sobering effects of neoclassicism on Russian design. The deep cobalt-blue glaze covering most of the surface emphasizes the delicate quality of the complicated gilding. The era's interest in the ancient world is further emphasized by the continuous scene from an as-yet-unidentified classical tale, here indicated by the presence of cupids and figures in ancient dress.

Green Wine Glass
St. Petersburg Glassworks
St. Petersburg, late 18th century

In the early 18th century, Russian goblets, like others in Europe, were made in imitation of metal vessels and the stems and bowls were often faceted. Under the austere influence of neoclassicism, the silhouette of this piece has been refined to the purest of shapes. The ornamentation is equally austere, eschewing cutting and engraving techniques in favor of a balanced and delicate pattern of swags, floral sprays, and the owner's initials rendered in silver.

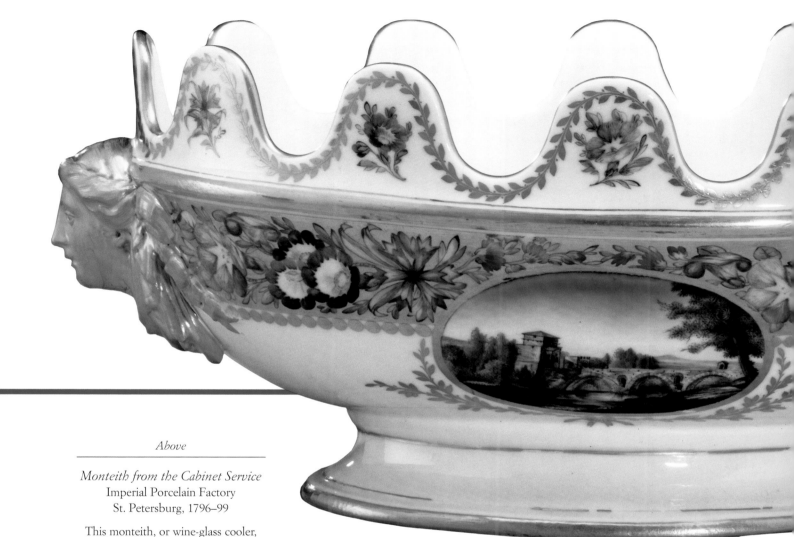

Above

Monteith from the Cabinet Service
Imperial Porcelain Factory
St. Petersburg, 1796–99

This monteith, or wine-glass cooler,
was part of a service Catherine the
Great commissioned for her Chief
Minister, Aleksandr Bezborodko.
Before serving wine, glasses were
cooled by hanging their feet from the
notched rims. The bowl of each glass
would then be suspended in the icy
water contained in the monteith. Each
piece of this service featured a view of
an Italian architectural site. It has been
argued that the images on the service
were chosen to stimulate learned
conversation about Italy's historic sites
among the aristocratic visitors.

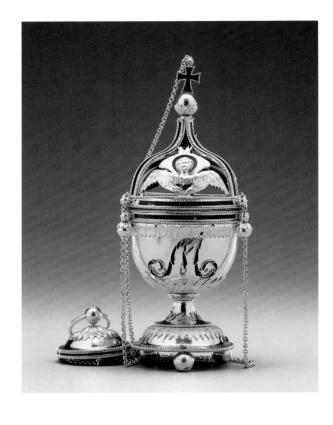

Left

Chalice
Iver Windfeldt Buch
St. Petersburg, 1791

In 1791, Catherine the Great presented a liturgical set, of which this chalice is a piece, to the Trinity Cathedral in the Aleksandr Nevskii Monastery in St. Petersburg. To ornament the set, Catherine provided Buch with gold and diamonds from the State Treasury. Carved gems representing scenes from the life of Christ, saints, and even a 13th-century Byzantine cameo of the Archangel Michael came from her private collection.

Above

Censer
I.P. Krag
Moscow, 1797

This church censer from early in the reign of Paul I, demonstrates the important influence of neoclassicism on traditional Russian forms. While older censers were fashioned in the form of a church, this silver gilt and blue enamel piece bears a more balanced, simplified composition that is embellished with repetitive leaf forms that were borrowed from classical and Renaissance vessels.

Empire and the Napoleonic Wars

Alexander I
1801–1825

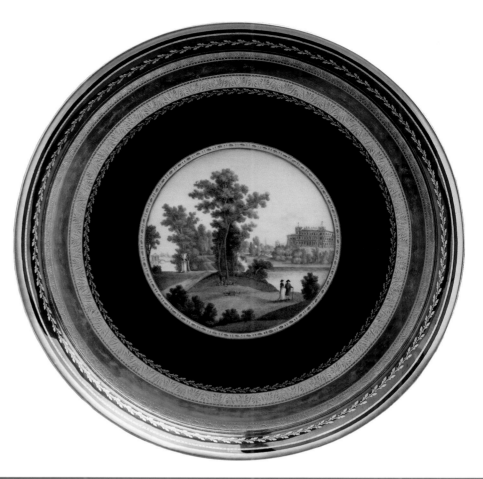

Above

Bust of Alexander I
c. 1810

Above right

Tray from a Tea and Coffee Service in Brown Lustre
Imperial Porcelain Factory
St. Petersburg, 1801–15

This tray from a tea and coffee service is decorated with a delicate scene of Gatchina, an imperial palace outside St. Petersburg that had been a favorite of Paul I. The inclusion of a prominent example of Russian architecture contrasts with the more traditional Italian scenes on the service's other pieces and suggests that Russians were beginning to see their own culture as equal to that of their European neighbors.

When Alexander assumed the throne in 1801, he followed the example of both his parents and his grandmother in embellishing St. Petersburg. He commissioned some of the northern capital's most important neoclassical buildings, adding immeasurably to the city's distinctive face and making it a fitting backdrop for Russia's rise to the forefront of European politics. The victories of the Russian army in the Napoleonic wars, the important part Russia played in the defeat of France, and the young Emperor's participation at the post-war Congress of Vienna lent the vast country a European status and prestige that it had never enjoyed before.

The joys of those Russian triumphs permeated the design of the period: images of heroic generals or important battles decorated everything from great canvases to modest pieces made for the middle-class. A particularly popular group of exquisitely cut glass goblets emblazoned with white glass medallions bore lines of patriotic poetry, classicizing portraits of the handsome young emperor, or images of the generals who had made Russia one of Europe's most powerful countries.

These small pieces, often displayed in cabinets singly or in groups, provide the first inkling of the nineteenth-century taste for more modest decorative arts

Vase with Scenes from Ovid's
Metamorphoses
Imperial Porcelain Factory
St. Petersburg, 1810–20
(detail)

The scenes on this vase are copied
from paintings attributed to followers
of the artist Raphael which hung in the
Hermitage. While the vase's silhouette
and its decoration based on Ovid's
Metamorphoses are inspired by the
classical world, the striking green glaze
and the twisting form of the mermaid-
handles demonstrate how designers in
this period often reinterpreted ancient
sources.

produced for a domestic setting.
During the remainder of the
century, patrons would eschew
grand pieces suitable for cavernous
interiors in favor of objects that
blend with, rather than overwhelm,
more intimately sized rooms. At
the same time, however, the
Imperial Porcelain Factory
continued to produce large vases
with intricately sculpted handles
and highly detailed painted scenes.

Above left	*Above center*	*Above*

Above left

Goblet
Imperial or Bakhmetev Glassworks
St. Petersburg, after 1814

The jubilant inscription—Rejoice Moscow! Paris was taken by the Russians!—on the front of this goblet recalls the public celebrations held in St. Petersburg on April 15, 1814, after news of the successful invasion of the French capital on March 19, 1814, reached the city. This phrase, a refrain from a patriotic song that premiered that evening, was inscribed on numerous finely cut glasses as a proud reminder of the nation's military primacy.

Above center

Saltcellar
Russia, early 19th century

Both the somber urn-like silhouette and the simple pattern of wreaths, swags, and leaves on this silver saltcellar are the product of a developing taste for classical motifs in Russian art.

Above

Goblet with Portrait of Count Wittgenstein
Imperial or Bakhmetev Glassworks
St. Petersburg, after 1814

The simplicity of cutting and massive proportions of this piece are both products of new styles that developed around the turn of the century. In the case of this piece, the simplicity of decoration allows the viewer to focus on the minutely rendered profile portrait of the General Count Petr Wittgenstein, commander of the forces guarding St. Petersburg from Napoleon's troops in 1812. His defense made him the object of public admiration and his portrait decorated commemorative objects of every sort.

Eclecticism and Historicism

Nicholas I and Alexander II

1825–1881

Critics have harshly judged the rigidly disciplined Nicholas I for putting down the Decembrist uprising in 1825 and for ruthlessly punishing its leaders, mostly men from prominent Russian families who had hoped to create a constitutional government. Historical opinion has, however, overlooked the cultural flowering that took place during his reign, suggesting that it happened in spite of, rather than because of his policies.

In fact, Nicholas showed himself to be quite a connoisseur, championing a variety of competing styles, which results in his reign being dubbed "eclectic." The Imperial Porcelain Factory, Imperial Glassworks, and other court artists and artisans produced luxurious objects that imitate historic styles ranging from the Gothic and Renaissance periods to echoes of Egyptian and Classical Antiquity popularized with the excavations of Egyptian, Etruscan, and Roman cities.

Perhaps the most important of these historicist styles was the

Above top

Portrait of Nicholas I
after Franz Krüger, 1850–51

Above

Portrait of Alexander II
artist unknown, 1870s

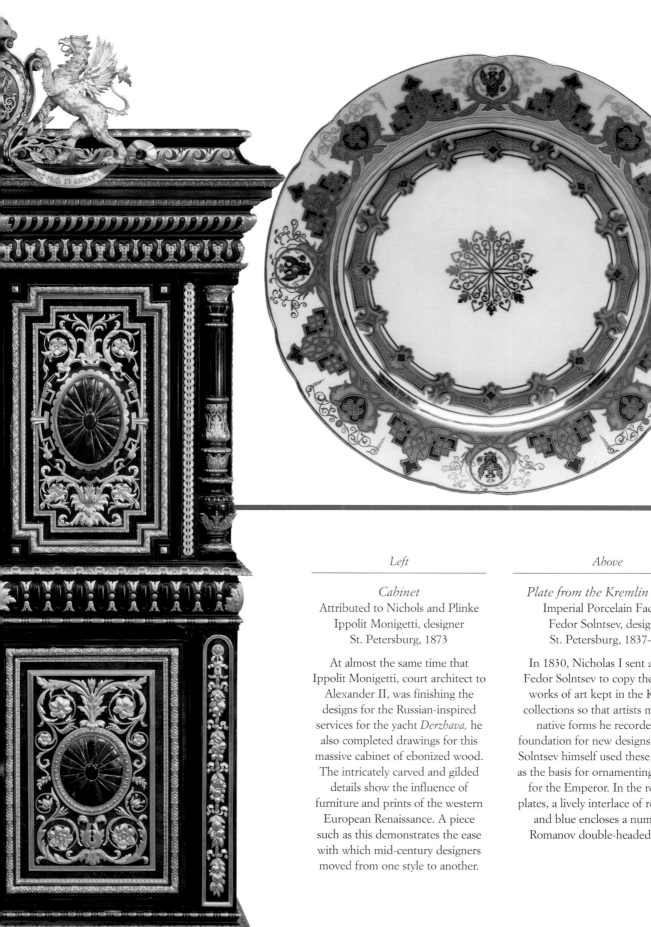

Left

Cabinet
Attributed to Nichols and Plinke
Ippolit Monigetti, designer
St. Petersburg, 1873

At almost the same time that
Ippolit Monigetti, court architect to
Alexander II, was finishing the
designs for the Russian-inspired
services for the yacht *Derzhava,* he
also completed drawings for this
massive cabinet of ebonized wood.
The intricately carved and gilded
details show the influence of
furniture and prints of the western
European Renaissance. A piece
such as this demonstrates the ease
with which mid-century designers
moved from one style to another.

Above

Plate from the Kremlin Service
Imperial Porcelain Factory
Fedor Solntsev, designer
St. Petersburg, 1837–55

In 1830, Nicholas I sent a young
Fedor Solntsev to copy the ancient
works of art kept in the Kremlin
collections so that artists might use
native forms he recorded as a
foundation for new designs. In 1837,
Solntsev himself used these drawings
as the basis for ornamenting a service
for the Emperor. In the resulting
plates, a lively interlace of red, green,
and blue encloses a number of
Romanov double-headed eagles.

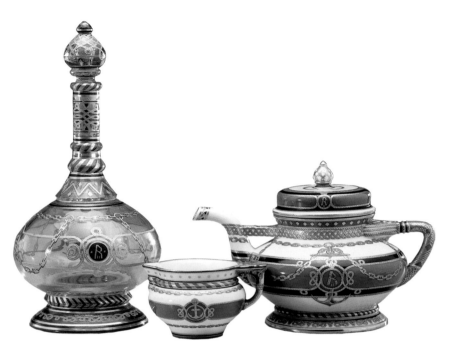

Left

Pieces from the Service for the Yacht Derzhava
Imperial Porcelain Factory,
Imperial Glassworks
Ippolit Monigetti, designer
St. Petersburg, 1871–73

These pieces from the service made for the imperial yacht *Derzhava* are aptly decorated with nautical motifs of chains, ropes, and anchors rendered in gold with black outlines on a green, blue, and white ground. Ippolit Monigetti, court architect to Alexander II, had been commissioned to create a harmonious decorative scheme for all the furnishings of the yacht's interiors, including the tableware. Monigetti's rather ingenious solution to this problem was to interweave nautical elements in a manner that recalled Old Russian ornament.

so-called Russian style. This style, visible in the Kremlin Service plate, emerged from the scholarly research of a number of architects and designers who documented Russian architecture, ornament, and design of the period known as pre-Petrine, i.e. prior to the accession of the westernizing Peter the Great. The complicated interlace that once embellished the margins of Slavic manuscripts appear on Imperial porcelain and glass. The Russian style held sway for the rest of the nineteenth century. During the reign of Nicholas I's successor, Alexander II, it became an ideologically charged, even nationalistic,

statement of Russian patriotism, particularly favored by wealthy business people.

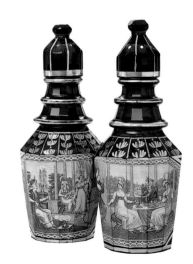

Left

Pair of Blue Glass Casters Transfer-Printed with Scenes of Turkish Interiors
Imperial Glassworks
St. Petersburg, after 1840

The imperial factories often pursued new technologies of decorating their wares just as they investigated myriad styles and ornament. In 1840, two workers developed a method of printing on glass at the Imperial Glassworks. In the following decade, the factory produced numerous pieces of colored glass whose brightly colored surfaces were decorated with black and white portraits of the Emperor and Empress, copies of Old Master prints or paintings, and, in this case, exotic scenes depicting imaginary Eastern interiors.

The End of Empire

Alexander III and Nicholas II 1881–1917

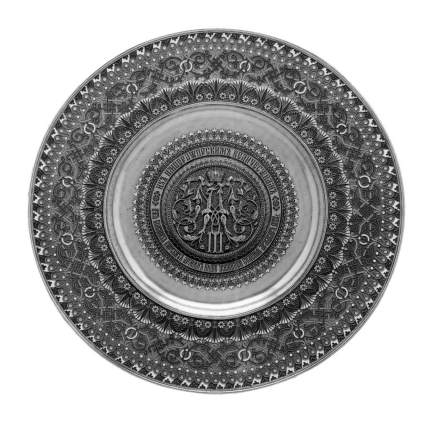

Above top

Portrait of Alexander III
Aleksandr Pershakov
1880s

Above

Portrait of Nicholas II
Mikhail Rundaltsov
1912

Emperor Alexander III, like many of his forebears, actively collected art. His interests (as well as those of wealthy entrepreneurs) focused especially on Russian artists, which helped energize the market for Russian art. A typical product of the time, the monumental painting *A Boyar Wedding Feast* enjoyed wide public popularity. Its complex evocation of the color and extravagance of the life of the *boyars*, Russia's noble class during the seventeenth century, responded to an increasing fascination with native cultural traditions.

But the ruling Romanov family and Russia's elite were not only inwardly focused. Indeed, the name of the jeweler Carl Fabergé became intimately linked with the

Above

Bread and Salt Dish
Firm of Pavel Ovchinnikov
Moscow, 1888

The presentation of a loaf of fresh bread topped by a cellar of salt to a visiting dignitary is a traditional Russian ceremony of welcome. Residents of the village of Armavir in the Caucasus commissioned this elaborately enameled dish to welcome Emperor Alexander III, his wife, and son during their 1888 visit. After the ceremonies were completed, the dish, with its accompanying inscription identifying the givers, commemorated the sovereign's visit.

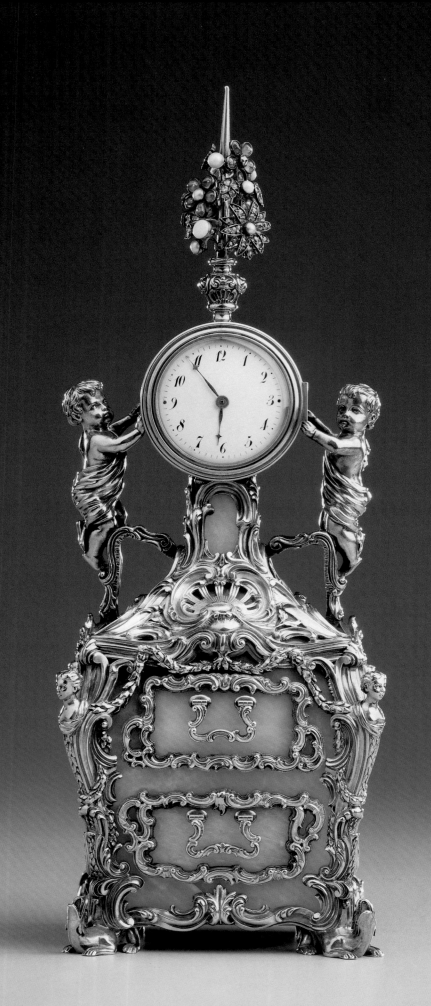

Clock
Firm of Carl Fabergé
Julius Rappoport, workmaster
St. Petersburg, 1894–96

As this clock demonstrates, famed
Russian designer Carl Fabergé
borrowed ideas not only from 18th-
century France but also from the
English rococo. An 18th-century clock
attributed to James Cox served as the
basis for the piece in the Hillwood
collection. According to legend, Maria
Fedorovna, Alexandra's mother-in-law,
admired the English clock by Cox,
that was owned by Alexandra.
Nicholas and Alexandra then
commissioned Fabergé to create a new
piece as a gift for Maria, whose
monogram appears on the back. To
create the clock in the Hillwood
collection, Fabergé both copied and
altered details from his model.

last of Russia's tsars. While
paintings like *A Boyar Wedding
Feast* demonstrate the continuing
importance of Russian traditions
and history, Fabergé's delicate
creations represent a look back
to a more western European past.
For example, the firm's clock in
the form of a chest of drawers
borrows elements from both
eighteenth-century France and
English rococo. Of course,
Fabergé became best known for
the fantastic jeweled Easter eggs.
Hillwood's Catherine the Great
Egg was an Easter gift from
Nicholas II to his mother in 1914;
the delicate miniatures on the egg,
like the clock, recall European
painting and ornament of the
eighteenth century.

Catherine the Great Easter Egg
Firm of Carl Fabergé
Henrik Wigström, workmaster,
Vasilii Zuev, miniaturist
1914

Henrik Wigström, Fabergé's last head
workmaster, created this egg for
Nicholas II to present to his mother,
Maria Fedorovna, on Easter morning
in 1914. The firm's designer, Vasilii
Zuev, painted the pink enamel panels
with miniature allegorical scenes of the
arts and sciences after French artist
François Boucher. According to a
letter of Maria Fedorovna, the surprise
in this egg was a tiny figure of
Catherine the Great seated in a
mechanical sedan chair. (It has since
been lost.)

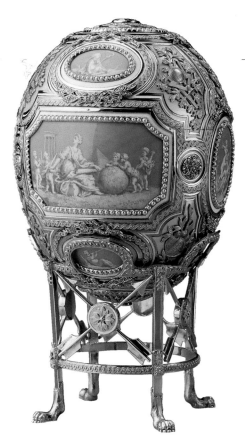

A Boyar Wedding Feast
Konstantin Makovskii
1883

This enormous painting depicts
one of the most important social
and political events of Old Russia,
a wedding uniting two families of
the powerful boyar class that
dominated Muscovite politics in
the 16th and 17th centuries. With
this painting, Makovskii developed
a stylistic formula that he
successfully recycled throughout
the rest of his life. His paintings,
which became extremely popular
with the public, evoked the
romance, color, extravagance, and
theatricality that his
contemporaries imagined had
existed in boyar life.

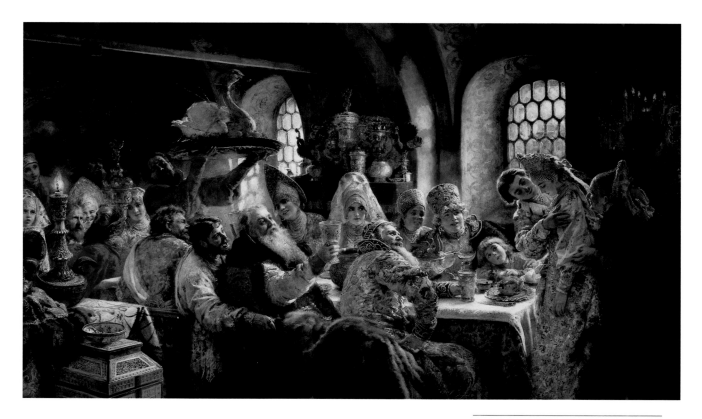

Reigns of French Monarchs and Periods

Louis XIV
1643–1715

Louis XV
1715–74

Louis XVI
1774–92

Revolution
1792–95

Directoire
1795–99

Consulate
1799–1804

Empire-Napoleon
1804–14

Louis XVIII
1814–24

Charles X
1824–30

Louis Philippe
1830–48

Napoleon III
1848–70

Bread and Salt Dish
Firm of Pavel Ovchinnikov
Moscow, 1883

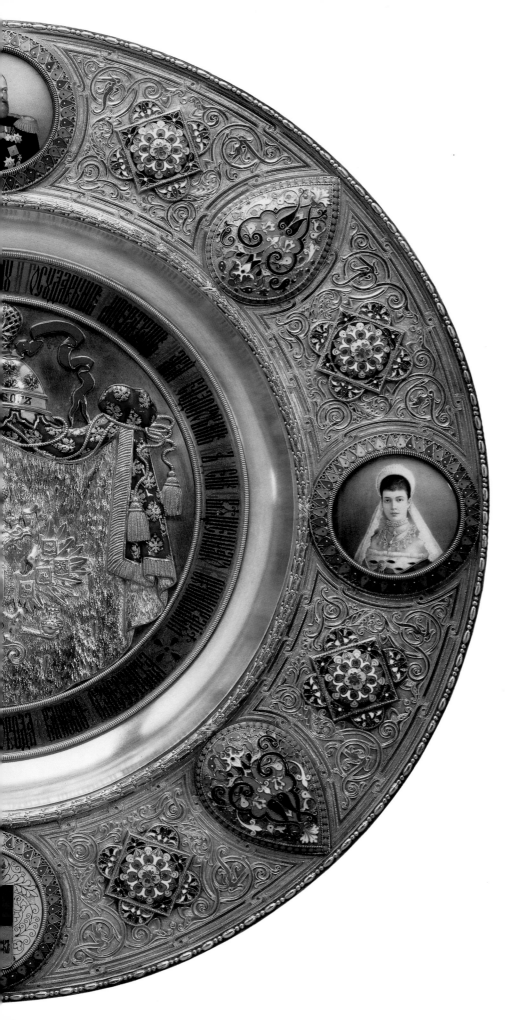

Reigns of
Russian Monarchs

Michael
1613–45

Alexis
1645–76

Fedor
1676–82

Peter I
(Peter the Great)
1682–1725

Catherine I
1725–27

Peter II
1727–30

Anna Ioannovna
1730–40

Ivan IV
1740–41

Elizabeth I
1741–61

Peter III
1761–62

Catherine II
(Catherine the Great)
1762–96

Paul I
1796–1801

Alexander I
1801–25

Nicholas I
1825–55

Alexander II
1855–81

Alexander III
1881–94

Nicholas II
1894–1917

Spring
Blooms

Aesculus pavia
red buckeye

Ajuga repans
bugleweed

Amelanchier species
serviceberry

Azalea species and
hybrids

Camellia japonica
Japanese camellia

Cercis canadensis
redbud

*Chaenomeles
japonica*
flowering quince

Chionanthus retusus
Chinese fringetree

Clematis montana
var. *rubens*
anemone clematis

Magnolia stellata
star magnolia

Malus species and
hybrids
crabapple

Myosotis scorpioides
forget-me-not

Narcissus species and
hybrids
daffodil

*Pachysandra
procumbens*
Allegheney pachysandra

Paeonia hybrids
peony

*Paulownia
tomentosa*
Empress tree

Pieris japonica
Japanese pieris

Prunus cerisifera
'Hollywood'
purpleleaf plum

Summer
Blooms

Abelia x grandiflora
glossy abelia

*Aesculus
hipposcastanum*
common horsechestnut

Cladrastis kentuckea
American yellowwood

Clethra alnifolia
'Hummingbird'
summersweet

Hosta species and
hybrids
plantain lily

Hydrangea species
hydrangea

*Hypericum
calycinum*
Aaronsbeard St.
Johnswort

Itea virginica 'Henry's
Garnet'
Virginia sweetspire

Plants of Seasonal Interest

Cornus florida
flowering dogwood

Deutzia species
deutzia

Exochorda giraldii
redbud pearlbush

Forsythia species
forsythia

Halesia tetraptera
Carolina silverbell

*Hyacinthoides
hispanica*
Spanish bluebells

Iris germanica
bearded iris

*Lorapetalum
chinense*
Chinese fringe-flower

*Magnolia x
soulangiana*
saucer magnolia

Prunus species and
hybrids
flowering cherry

Rhododendron species
and hybrids

Rosa floribunda
floribunda rose

Spiraea species and
hybrids
spirea

Syringa vulgaris
lilac

Tulipa species and
hybrids
tulips

Viburnum species
viburnum

Vinca minor
common periwinkle

Wisteria floribunda
Japanese wisteria

Jasminum floridum
showy jasmine

Kalmia latifolia
mountain-laurel

Kolkwitzia amabilis
beautybush

Lagerstroemia indica
crapemyrtle

*Leucothoe
fontanesiana*
drooping leucothoe

Liriope species
lilyturf

Lonicera maackii
amur honeysuckle

Magnolia grandiflora
southern magnolia

*Philadelphus
coronarius*
mockorange

Rosa hybrids
hybrid roses

Spiraea japonica
Japanese spirea

Syringa reticulata
Japanese tree lilac

Ulmus americana
American elm

Viburnum species
viburnum

Weigela florida
old fashioned weigela

Fall
Blooms, Foliage, Fruit

Acer species
maples (foliage)

Amelanchier species
serviceberry (foliage and fruit)

Aronia arbutifolia
'Brilliantissima'
red chokeberry (foliage and fruit)

Camellia sasanqua
sasanqua camellia
(bloom)

Ceratostigma plumbaginoides
leadwort (bloom and foliage)

Chrysanthemum
hybrids
chrysanthemum (bloom)

Colchicum autumnale
fall crocus (bloom)

Cornus florida
flowering dogwood
(fruit and foliage)

Fothergilla gardenii
dwarf fothergilla
(foliage)

Ginkgo biloba
ginkgo (foliage)

Hamamelis virginiana
common witchhazel
(bloom)

Itea virginica
'Henry's Garnet'
Virginia sweetspire
(foliage)

Liriodendron tulipifera
tulip poplar (foliage)

Malus species and
hybrids
Crabapple (fruit)

Metasequoia glyptostroboides
dawn redwood (foliage)

Pyracantha koidzumii
Formosa firethorn (fruit)

Viburnum species
Viburnum (fruit and
foliage)

Winter
Blooms, Foliage, Fruit, Bark

Aucuba japonica
Japanese aucuba

Betula platyphylla
var. *japonica*
'Whitespire'
Asian white birch (bark)

Buxus sempervirens
English boxwood

Chamaecyparis species
falsecypress (foliage)

Chimonanthus praecox
fragrant wintersweet
(bloom)

Cornus sericea
redosier dogwood (twig
bark)

Corylopsis species
Winter hazel (bloom)

Crocus species
(bloom)

Cryptomeria japonica
Japanese cryptomeria
(foliage)

Cunninghamia lanceolata 'Glauca'
Chinafir (foliage)

Galanthus species
Snowdrops (bloom)

Ilex species and hybrids
holly (fruit and foliage)

Jasminum nudiflorum
winter jasmine (bloom)

Hamamelis x
intermedia
hybrid witchhazel
(bloom)

Mahonia bealei
leatherleaf mahonia
(bloom and foliage)

Magnolia grandiflora
southern magnolia
(foliage)

Nandina domestica
heavenly bamboo (fruit
and foliage)

Sarcococca hookeriana var.
humilis
sweetbox (bloom and
foliage)

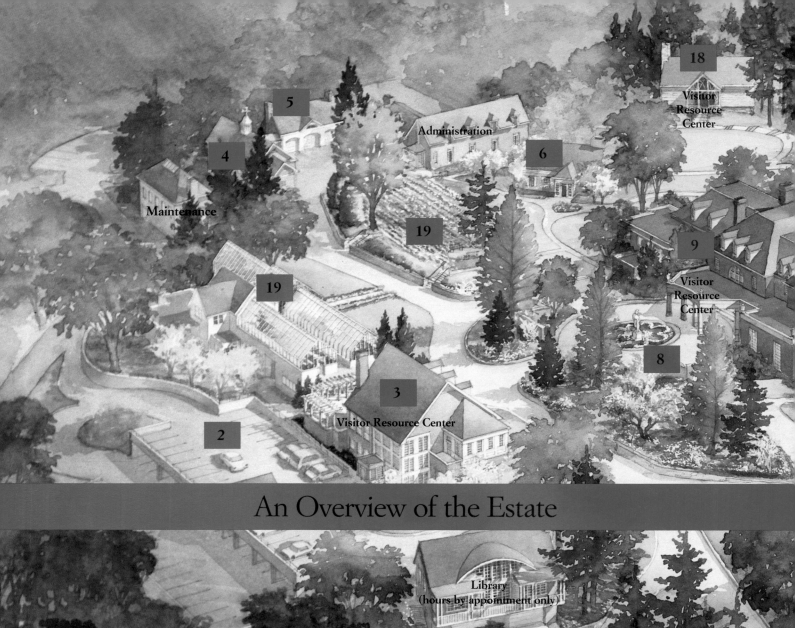

18

Visitor Resource Center

5

4

Administration

6

9

Visitor Resource Center

19

19

8

3

Visitor Resource Center

2

An Overview of the Estate

Library
(hours by appointment only)

Private Residence

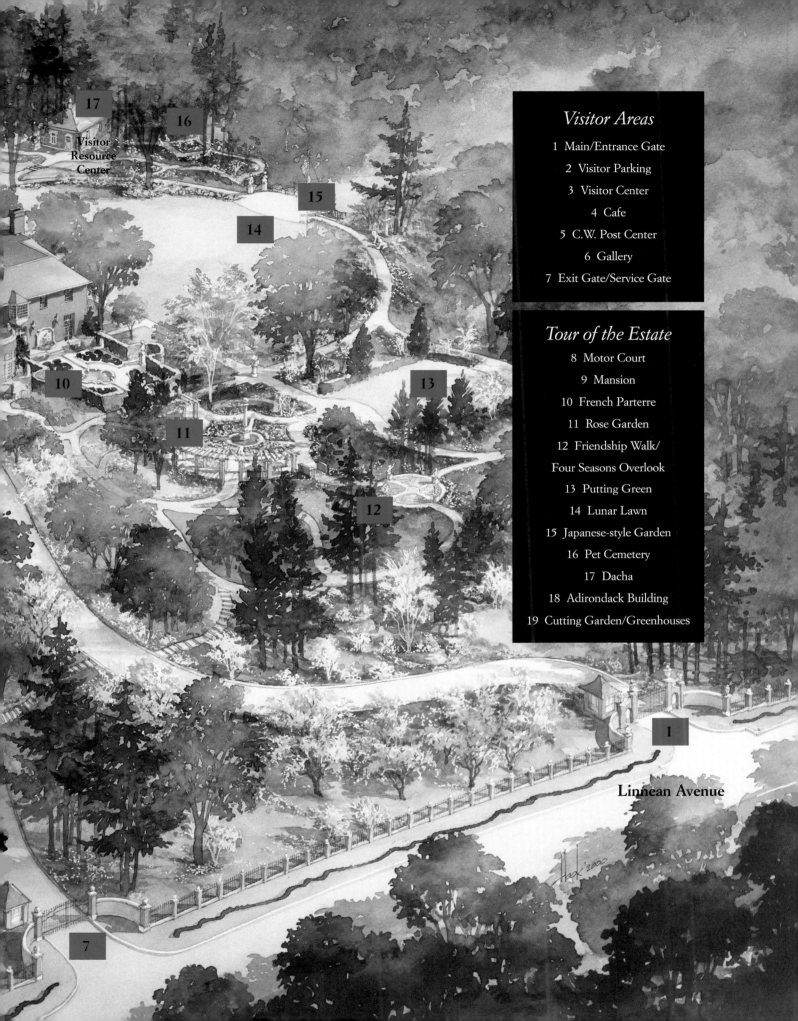

Visitor Areas

1 Main/Entrance Gate

2 Visitor Parking

3 Visitor Center

4 Cafe

5 C.W. Post Center

6 Gallery

7 Exit Gate/Service Gate

Tour of the Estate

8 Motor Court

9 Mansion

10 French Parterre

11 Rose Garden

12 Friendship Walk/
Four Seasons Overlook

13 Putting Green

14 Lunar Lawn

15 Japanese-style Garden

16 Pet Cemetery

17 Dacha

18 Adirondack Building

19 Cutting Garden/Greenhouses

Visitor Resource Center

Linnean Avenue

Colophon

Editor: Donald Garfield

Designer: Polly Franchine

Printer: Schneidereith and Sons, Inc.

Estate overview: William Hook

Photography throughout this book, unless noted below, is by Edward Owen.

Photo credits
Lee Anderson, p. 39
Harlan Hambright, front cover, pp. 4, 42–43
Bill Johnson, p. 52
Robert Lautman, pp. 26–27, 36–37
Peter Rovzitsky, pp. 49, 53 top left
Ann Stevens, pp. 7, 46–47, 48, 50, 51, 53, 54, 100–101, 104

Photographs on pp. 24–25, 32–33, 34–35, and 41, courtesy Hal C. Conroy; p. 9, bottom: courtesy The Isabella Stewart Gardner Museum, Boston, Massachusetts; p. 10, courtesy The Frick Collection, New York, New York; p. 11, above: courtesy The Henry Francis du Pont Winterthur Museum, Winterthur, Delaware; p. 11, below: courtesy The Huntington Library, Art Collections and Botanical Gardens, San Marino, California; pp. 15, 21, courtesy Hillwood Museum; p. 18 top, courtesy Associated Press; p. 19 top, courtesy Vogue Magazine.